# HISTORY *of*
# DAVIS ISLANDS

# HISTORY *of*
# DAVIS ISLANDS
### DAVID P. DAVIS AND THE STORY OF A
### LANDMARK TAMPA NEIGHBORHOOD

## RODNEY KITE-POWELL

Charleston  London

THE
History
PRESS

Published by The History Press
Charleston, SC 29403
www.historypress.net

Copyright © 2013 by Rodney Kite-Powell
All rights reserved

First published 2013

Manufactured in the United States

ISBN 978.1.60949.873.3

Library of Congress CIP data applied for.

# CONTENTS

# PREFACE

Ten years ago, I finished the introduction to my master's thesis on D.P. Davis with a note to two of my best friends, "Let's go fishing." Much has changed since I wrote those words. Sure, I still enjoy fishing with my friends, and I have the same job with the same museum. But I now have an amazing wife and wonderful stepson, and the museum I work for is in a gleaming new home ten times the size of the old place where many of the artifacts, documents and photographs relating to Davis Islands were first collected.

I have met and worked with some incredible people in the process of researching the life of David Davis, and they have all contributed in some way to the completion of this work. When I first began this study in the late 1990s, I encountered a group of people across the state that was eager to share their information and expertise. Joe Knetsch is a researcher's best friend. He is always on the lookout for some bit of information and comes up with some amazing material. The state of Florida is lucky to have someone as diligent as Joe. Robert Kerstein, political science professor at the University of Tampa, has also been a great help and a great friend, providing insight into Tampa's political history and reading previous drafts of this work. Professor John Belohlavek at the University of South Florida offered encouragement and suggestions along the way as well.

Two of the greatest contributors to the study of Tampa history, Gary Mormino and Leland Hawes, were also two of my greatest supporters. Gary read numerous drafts and guided my research during my time as one

of his graduate students and into my professional life, giving both needed encouragement and patient criticism. Leland read drafts of the manuscript, giving me insights and suggestions that could only come from someone with his knowledge and experience. I am forever grateful to them both and deeply saddened that Leland did not survive to see the publication of this work.

Frank North, past president of the Tampa Historical Society and editor of the society's journal, the *Sunland Tribune*, provided me with an outlet for sections of this work, as well as information on his aunt Billy, who worked for D.P. Davis Properties in Tampa in 1925. He did all this before I had the sense to marry his daughter. Frank's abilities with publishing and editing were second only to his skills as a father, father-in-law and grandfather. He passed away on Easter Sunday 2013 far before his time. His love of history lives on, in part, in this book.

Several institutions have been extremely helpful in providing research materials and assistance throughout this endeavor. The Tampa Bay History Center in particular has been accommodating, both in furnishing information and photographs of Davis, his family and Davis Islands and for allowing me the opportunity to pursue my goal of writing about Davis's life. Colleagues past and present, including president and CEO C.J. Roberts and curator of collections Travis Puterbaugh, have been very supportive through the years. The other major libraries in Tampa, the John F. Germany Public Library and the library at the University of South Florida, also hold vast collections of materials relating to Tampa history. Andy Huse at USF has been especially helpful, both with the library's collection and in discussions about Davis and Davis Islands. In addition, the City of Tampa's Archives and Records Services maintains the records of Davis's deals with the City of Tampa, including the contract signed in 1924 for the purchase of the small islands that would become Davis Islands. Curtis Welch, the former assistant city archivist for the City of Tampa, was an immense help. Lynn Hoffman and Mary E. Murphy-Hoffman at the Putnam County Archives supplied me with a surprising amount of information on the Davis family, including photographs of gravestones and information on the family patriarch, George Mercer Davis. Charles Tingley at the St. Augustine Historical Society also proved invaluable, assisting me with my research on Davis Shores on Anastasia Island.

In the intervening ten years, new friends and colleagues have entered my life and the world of D.P. Davis and Davis Islands. Lee Medart, former publisher of the *Davis Islands News*, took an interest in my work on Davis Islands and offered space in her newspaper for me to publish a monthly

history column. Much of the research in this book grew from those columns. Lee also provided an introduction to the Davis family, including to D.P.'s sons, that I would have thought impossible. George Riley Davis II, his brother, David Paul Jr., and their families opened their homes to this stranger from Tampa and were very patient while I asked very personal questions about Davis, his life and his death. Nancy Davis, who is married to David Paul Jr.'s son, Greg, has been my main conduit into the California Davises and has been a great resource and friend. Additionally, I would be remiss if I failed to thank the wonderful people at The History Press. Editors Chad Rhoad and Julia Turner may be new to the world of D.P. Davis and Davis Islands, but they have been very supportive, patient and encouraging throughout the submission and publication process.

Finally, this book and its author would still be stuck in neutral if not for my wife, Krissy. She has read every word and, more importantly, kept me moving forward both toward the pursuit of the book's publication and on to my final deadline. The love and support that she and her son, Lucas, have brought into my life are immeasurable.

All of these incredible people did their part and did it well. Any inaccuracies or mistakes are my own.

# CHAPTER 1
# FLORIDA ROOTS

## DAVID PAUL DAVIS AND THE FLORIDA LAND BOOM

The 1920s real estate boom in Florida caused a sensation across the United States. Hundreds of thousands of people, more mobile than ever in their Ford Model Ts, Oldsmobile 8s and Studebakers, took to newly constructed highways and headed south into an expected paradise. They searched for palm-lined streets paved with gold and year-round sunshine with profits sprouting from the sandy soil.

A profusion of real estate pitchmen awaited the southbound throng, hoping to separate fools from their money. From this frenzy of hucksters emerged several professional developers who earnestly desired to change and, in their minds, improve the landscape of Florida. The names Carl Graham Fisher, Addison and Wilson Mizner and George E. Merrick readily come to mind when considering the pantheon of the Florida land boom. More often than not, one particular Florida real estate mogul is relegated to second-tier status or neglected altogether. This is unfortunate considering his accomplishments: numerous developments in Miami, completion of projects in Cocoa Beach and Tampa and near completion of a development on Anastasia Island in St. Augustine. David Paul Davis achieved all this between 1920 and 1926. More unusual still, he was a Florida native and dabbler in real estate as early as 1907.[1]

Davis disappeared as quickly as he appeared. His death in 1926, ruled an accidental drowning, resulted from a fall out of a stateroom window on the luxury liner RMS *Majestic*. The ship's captain ordered an immediate search of the dark Atlantic waters. The ship circled continuously for over an hour, lights scanning every inch of ocean within sight, but to no avail.

Biographers have continued to search for Davis through the years, but they, too, have been stymied—not by darkness and deep water, but by the incredible stories concocted during his lifetime, some of which Davis himself manufactured in an effort to craft his own unique image. His life is shrouded in the kind of myths that could only come out of the frenzy of the Florida land boom. The fate of his Tampa development, Davis Islands, was also in limbo. Indeed, the future of the islands project looked bleak when Davis died in October 1926.

# The Davis Family

David Paul Davis was born on November 29, 1885, in the North Florida town of Green Cove Springs, the county seat of Clay County, to Gertrude Margaret Davis and her husband, George Riley Davis. The small town, situated on the western bank of the St. Johns River about twenty-five miles south of Jacksonville, supported trade and tourism between the big river and the agricultural towns of north central Florida. The major draw to Green Cove Springs was the springs themselves, thought to hold incredible medicinal powers. A large resort, the Clarendon House, catered to weary northerners attempting to escape the harsh winter climate.[2]

Both sets of David's grandparents made their way into Florida in the nineteenth century. His maternal grandparents, Scottish-born David Paul Fraser and his wife, New Yorker Elizabeth McKinnon, also selected North Florida as their new home. They moved to Jacksonville in 1880, joining a small influx of people who pushed the city's population to 7,650, making it the second-largest city in Florida. David Fraser, according to his obituary, was a beloved citizen of Jacksonville who forever endeared himself with the people in his adopted hometown following the disastrous 1901 Jacksonville Fire.[3]

Davis's paternal grandfather, George Mercer Davis, came to Florida from South Carolina in 1853. Florida was among the newest states in the Union at the time, having earned statehood in 1845. Settlers such as Davis streamed

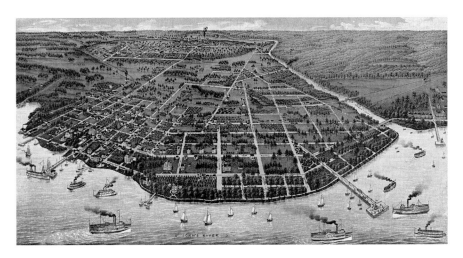

This bird's-eye view of Green Cove Springs, Florida, was created in 1885, the same year that David P. Davis was born in the north Florida city. The springs in the vicinity were heralded as having curative powers. *Courtesy of the Library of Congress, Geography and Map Division.*

south to stake their claim in America's vast southernmost frontier. For the bulk of those recent arrivals, Florida only went as far south as Lake George, the source of the St. Johns River—to them North Florida was Florida.[4]

Born in Beauford, South Carolina, on April 26, 1832, George Mercer Davis came to Palatka, Florida, as a talented twenty-one-year-old carpenter. The hand-hewn rafters he supplied for St. Mark's Episcopal Church in 1854 were among his first major contributions to his new hometown. That same year, Davis married fellow South Carolinian Martha A. Baisden. The marriage took place in Palatka on May 5, with William Collier presiding. Eleven months later, in April 1855, the Davises welcomed Harriet "Hattie" Davis into the family, the first of eight children born to George and Martha Davis.[5]

The second Davis child, George Riley Davis, arrived on January 15, 1857. Like his sister, George Riley was born in Palatka. By this time, Palatka boasted many features befitting a growing town, including a sawmill, churches, a school and bustling trade. This growth was hampered by a damaging freeze in the winter of 1857. While not as severe as the freezes of 1835 or 1894–95, the drop in temperature drove many farmers out of business and kept tourists out of town.[6]

The people of Palatka soon recovered, but for some reason, the Davis family chose to leave sometime between 1857 and 1860, going upriver to the new settlement of Welaka, on the eastern bank of the St. Johns River, twenty

miles south of Palatka and seventy-five miles south of Jacksonville. Welaka, whose name is derived from a Seminole word meaning "chain of lakes" (an apt description of the St. Johns), had an economy similar to Palatka's. The poet Sidney Lanier, who traveled throughout Florida in the early 1870s, described this portion of the St. Johns River:

> *Twenty miles above* [Palatka], *on the east bank, one hundred miles* [sic] *from Jacksonville, is Welaka, the site of an old Indian village, and subsequently of a Spanish settlement. Here the St. Johns narrows to a third of a mile in width…Immediately opposite Welaka is the mouth of the Ocklawaha River.* [7]

According to the 1860 federal census, the family's new land held a value of $1,000, plus Davis had an additional $500 in personal property. George Mercer Davis also reported a different occupation, that of farmer. No details exist to explain why Davis shifted from being a carpenter to working the land or even that he completely gave up carpentry. The census does reveal that the Davis family lived better than most of their neighbors. Of the sixty-six total families counted in Welaka, only fourteen held more real estate and twenty-five owned more personal property. The census also lists a third child, one-year-old Nancy Davis. It is believed that she died in 1860—likely a casualty of Florida's high infant mortality rate during this time. [8]

## DAVIS FAMILY AND THE CIVIL WAR

The relative peace and progress of the Davis family, like that of almost every family in Florida if not the South, would soon be shattered. Long-simmering national tensions between North and South finally boiled over with the 1860 presidential election. South Carolina was the first state to leave the Union in protest over Abraham Lincoln's victory, followed by Mississippi on January 9, 1861. The next day, Florida's secession convention voted to depart. Soon, Florida would join a new nation, the Confederate States of America, headed by Mississippi's Jefferson Davis. Members of the Davis family were caught up in this early surge of Southern patriotism. When their fourth child was born in 1862, they named the boy Jeff, giving him the same name as the Confederate president. The family had returned to Palatka by this time, though nothing exists in the historic record to explain the move. [9]

George Mercer Davis enlisted, along with forty-four of his neighbors, in the Confederate army on August 2, 1862, in Palatka as a member of the First Partisan Rangers Battalion. His unit's designation would change to Company B, Second Florida Infantry Battalion (IB) on June 24, 1863. By that time, Davis had seen light action in the defense of his state. That would soon change. In late 1863, Davis and the Second Florida IB fought in two more engagements in Florida, both at Fort Brooke (Tampa). In May 1864, the battalion was transferred out of Florida's military department and into Finegan's Brigade, Mahone's Division, Third Corps, Army of Northern Virginia. Davis now found himself in the middle of the war. He and the Second Florida IB fought in the Battle of Cold Harbor (Virginia, June 1–3) and participated in the ill-fated defense of Petersburg (Virginia, June 1864–April 1865), two of the bloodiest engagements of the war. [10]

Perhaps the most overwhelming period of Davis's service in the Civil War was the Union siege of Petersburg, which began in June 1864. Davis's unit had again been reorganized, this time just prior to his arrival at Petersburg. Now a member of Company G, Tenth Florida Infantry, Davis and his fellow Confederates defended the Virginia city against Union attack. The besieged Rebels were at an extreme disadvantage; they were outnumbered, outgunned, hungry and poorly equipped. [11]

Arguably the most sensational episode of the siege was the Battle of the Crater on July 30, 1864. Union soldiers of the Forty-eighth Pennsylvania, led by Lieutenant Colonel Henry Pleasants, dug a 511-foot shaft underneath the Confederate lines. The former anthracite coal miners then dug a 75-foot powder chamber running parallel to and 20 feet below the Rebel positions. The chamber was filled with explosives, and at 4:44 a.m. on the morning of the battle, the command was given to blow it up. The initial blast, which opened up a crater nearly a quarter acre in size, killed or wounded 278 Confederate soldiers. The Rebels soon regrouped and began pouring a merciless fire down on Union troops, who had crowded into the crater in an attempt to get through the Confederate lines. By 9:30 in the morning, the battle was over. Total losses were 4,000 Union soldiers dead, wounded or missing and 1,300 Confederate casualties, most of them wounded. The battle was a Confederate victory, but the morale of both sides sank in the aftermath. Unlike elsewhere along the Petersburg siege lines, there would be no more informal truces near the Crater, and sniper activity, always a problem, proved even more ferocious along this section of the line. [12]

Eventually, the rigors of military service, the prolonged separation from his wife and children and the growing hopelessness of the Confederate cause drove

Davis to desert the siege lines at Petersburg on August 22, 1864. He did not go alone. With him were Sergeant David A. Dunham and Private Alexander L. Davis, both of whom had enlisted with Davis in Palatka two years before. Two other Palatkans, Privates John Green and Lewis Roberts, were killed at Petersburg before Davis's desertion. The three deserters, soon captured by Federal soldiers, took an oath and traveled to Philadelphia before beginning their slow passage back south toward home. The war, for them, was over.[13]

While George was away on the battle front, Martha kept things together on the homefront. Palatka was not physically ravaged, but it did see its share of adversity. The most intense episode occurred very early in the war, on October 7, 1862. The Union gunboat USS *Cimarron* arrived at Palatka to evacuate Union sympathizers from the area. The commander of the gunboat, Maxwell Woodhull, was told by former Florida governor William A. Moseley (who lived near Palatka) that no Confederate soldiers remained in the vicinity. At the same time, the gunboat's crew saw "armed and mounted men" in the center of town, near the present-day site of Westview Cemetery. The gun crews fired several shells and dispersed the small Rebel presence. Woodhull, infuriated at the lie Governor Moseley had just told, gave the order to torch the town. Palatka was saved by a Northern transplant, Mary Emily Boyd, who assured the Union commander that Moseley did not know about Confederate military movements and convinced Woodhull to spare the town.[14]

## A Time to Rebuild

George, like countless other disillusioned Southerners, eventually made his way back home and attempted to return to a normal life. North Florida experienced the ravages of war more than the southern section of the state, but it also experienced a fairly rapid recovery. Tourists soon trod where armies previously marched, and that unstoppable artery, the St. Johns River, would again pump life into Putnam County. Davis's family began to reflect this growth, adding four more children during the next five years. The first postbellum arrival was Charles, born in Palatka in 1867, trailed closely by Alice, born the following year. When the census taker arrived at the Davis family's Palatka home for the 1870 enumeration, he found the seven-member family led by thirty-nine-year-old George, who had returned to work as a carpenter. Martha, forty-one at the time of the census, still held the responsibility of "keeping house" with help from fifteen-year-old

Harriet who, with her brothers George and Jeff, attended school. The two youngest, Charles and Alice, were not yet school aged. It is unfortunate that the 1870 census does not list real estate or personal property values for anyone in Putnam County, making it impossible at this point to see how the Davis family fared financially in the decade following the 1860 enumeration. Certainly they, like other Floridians of the time, were busy putting their lives back together as best they could.[15]

Ten years later, the Putnam County census taker again counted seven members in the Davis household. The family had changed, though. George Riley, then aged twenty-three, had moved out and his brother Jeff had either followed suit or passed away in the intervening ten years. Additions to the household, still led by carpenter George, included nine-year-old Sarah and seven-year-old Howell. Remaining at home was the oldest child, Harriet, still unmarried at age twenty-five. She undoubtedly helped her mother with housekeeping and child-rearing responsibilities. Those responsibilities were compounded by the seven renters sharing space in the Davis home. The 1880s would prove to be successful in many ways for the Davis family. Three children—Harriet, George Riley and Sarah—would each marry and have children, and George Mercer Davis would find financial success right in his own backyard.[16]

Harriet was courted by, and later married to, a local preacher named William Armistead. Eighteen years her senior, Armistead appears as one of the boarders at the Davis home in the 1880 census. The Virginia-born minister married Harriet on December 29, 1881, in a ceremony officiated by George K. Allen. Unlike the marriage of his sister, little is known about the marriage of George Riley Davis. According to the 1900 federal census, his wife, Gertrude Margaret Fraser, was born in Cuba in September 1867, making her ten years younger than George. The chart also lists the duration of marriage as seventeen years. This narrows their marriage date to 1883 or possibly 1882. Record of Sarah Davis's marriage can be found in the Putnam County marriage book. She married Samuel L. Lyon on May 29, 1889, at Palatka's First Baptist Church.[17]

In 1883, fifty-two-year-old George Mercer Davis began manufacturing cypress tanks and cisterns by hand in a small shop behind the family home, located at the corner of Lemon and Fifth Streets. The business continued to grow, and by 1892, Davis was joined by his youngest child, Howell, and the company was soon known as G.M. Davis & Son. They built a factory three blocks from the original location the following year, adding steel tower construction to their list of services. Their partnership would last until George Mercer Davis's death on June 11, 1896.[18]

CHAPTER 2

# GEORGE RILEY DAVIS
# AND FAMILY

At some point between 1870 and 1880, likely more toward the latter, George Riley Davis left his parents' home. He settled in Green Cove Springs, approximately thirty miles downriver from Palatka in neighboring Clay County. He does not appear in the 1880 census of either Clay or Putnam County, but that does not mean he did not live in one or the other area. George Riley is thought to have operated a steamboat along the St. Johns carrying passengers and freight along the north-flowing river. However, he may have traveled as far south as Key West or Cuba, Gertrude's birthplace, or he may have traveled north to Jacksonville. According to the 1920 federal census, Gertrude and her family had lived in the United States since 1880. An obituary for David P. Fraser, Gertrude's father, from a Davis family scrapbook, indicates that the family had lived in Jacksonville for quite some time. While not definitive proof, this would indicate that George and Gertrude likely met in Jacksonville.[19]

It is around this time, between 1882 and 1884, that George and Gertrude were married and had their first child, Elizabeth. In another unfortunate twist of history, the State of Florida Census for 1885 is incomplete, with several counties, including Clay County, presumably lost forever. Putnam County's census was preserved, though, and the elder Davis family is listed. What is known is that in Green Cove Springs on November 29 of that ill-fated census year, George and Gertrude welcomed their second child into the family—a son they named after Gertrude's father, David Paul.[20]

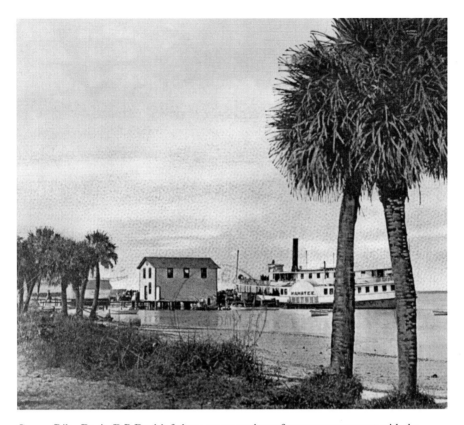

George Riley Davis, D.P. Davis's father, was an engineer for over twenty years with the Favorite Line of steamers plying the waters of Tampa Bay. He likely served aboard this steamboat, the *Manatee*, shown docked at Pass-a-Grille, circa 1912. His eighteen-year-old son, Dave, may have worked in 1903 as a mate with his father aboard this same ship. *Courtesy of the Florida State Archives.*

Guidebooks of the late nineteenth century painted Florida as a paradise. One of these, Rambler's *Guide to Florida*, described Green Cove Springs from the vantage point of the St. Johns River:

> *On rounding Magnolia Point, the steamer enters a beautiful bay where, in full view, lies Green Cove Springs, the Saratoga of the St. Johns. It is already a favorite resort, which possesses several of the best hotels in Florida. Its importance is assured.*[21]

Despite Rambler's bucolic description, George Riley Davis decided to move his young family, in 1895, from Green Cove Springs to another

fast-growing town—a city, in fact—located on Florida's west coast. North Florida had just endured the worst winter on record. Two successive freezes, the first in December 1894 and the second two months later, virtually wiped out Florida's citrus industry north of Orlando. This undoubtedly had an effect on the Davis family and George Davis's boating industry, of which citrus growers were a huge part. With his steamboat experience on the St. Johns, Davis landed a job with the Favorite Line of steamers, plying the warm waters of Tampa Bay as an engineer aboard the *Manatee*.[22]

# The Davis Family in Tampa

Tampa, the county seat of Hillsborough County and the Davises' new home, traced its history to the early days of Territorial Florida. The town grew along the northern boundary of a Federal military reservation known as Fort Brooke, established in 1824. The first post office, which opened in 1831, carried the name "Tampa Bay," but it was soon shortened to Tampa. The meaning and origin of the name has been debated for years, with no consensus, but a strong theory is it was the name of a native village (sometimes spelled Tanpa) on the bay.[23]

Judge Augustus Steele laid out the first town plots in 1838, but the United States government invalidated these because they included Fort Brooke property. In 1847, the federal government reduced the size of the fort and donated the excess land to Hillsborough County. The land was platted for sale, the proceeds of which funded the construction of a new county courthouse in Tampa. Tampa received a city charter from the State of Florida on December 15, 1855. Prosperity seemed certain, but national politics held different plans for Tampa and Hillsborough County.

The Confederate army held Fort Brooke throughout most of the Civil War. It was shelled by Union warships on several occasions and was captured in May 1864. After scouting the area for a day, the victors found nothing of use and abandoned the post. Federal troops returned after the war to occupy the town. In the years immediately following the war, the only profitable (legal) ventures in the Tampa area were fishing, logging and cattle ranching. As early as the 1850s, cattle traders established a route between Florida and Cuba and resumed the traffic shortly after the conclusion of the Civil War. Cubans paid for the cattle in gold, not inflation-prone paper money, so area ranchers soon were back on their feet.

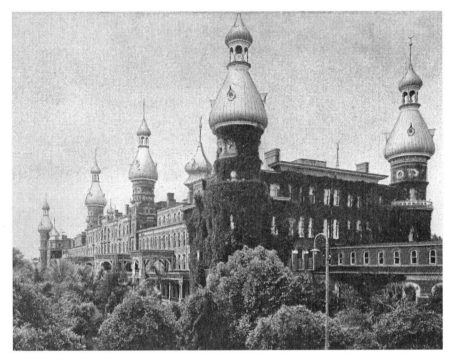

The Tampa Bay Hotel opened in February 1891, bringing elegance and distinction to a rough pioneer town. The Davis family had only been in Tampa for six years by this time, but they had already witnessed a great deal of growth in the south Florida city. *Courtesy of the Tampa Bay History Center Collection.*

Florida, and Tampa, however, remained destitute for almost two decades. Finally, in 1881, relief was on the horizon. The Jacksonville, Tampa & Key West secured the rights to extend its line into Tampa but financial hardship caused continued delays. Two years later, Henry Bradley Plant wanted to bring his new railroad south, and he selected Tampa as his railhead and confirmed that with the purchase of the JT&KW line. Plant's railroad arrived in early 1884, and the following year, construction began on Tampa's first two cigar factories, Sanchez y Haya and V.M. Ybor and Co., in a new industrial enclave—Ybor City. The railroad and cigars would shape Tampa like nothing else had. Plant improved the fledgling port at the southwestern tip of the Interbay Peninsula, and soon Port Tampa was shipping goods and people to and from harbors throughout the Gulf of Mexico. Hillsborough County's population grew, as did its prosperity. Tampa's population ballooned from 720 people in 1880 to 5,532 people just ten years later. Immigrants

from Cuba, Spain and Italy came to work in the cigar factories of Ybor City and, later, West Tampa. Tens, and later hundreds, of millions of hand-rolled cigars were produced in Tampa factories every year.

The same year that Ybor first came to Tampa (1885), pebble phosphate was discovered in a riverbed near Fort Meade in Polk County. Phosphate was later discovered in the Hillsborough River and in the largely undeveloped southern portion of Hillsborough County. Though not celebrated as much as the cigar industry and the railroad, the phosphate industry outlasted both. Tampa in 1895 still lagged behind Jacksonville, Key West and Pensacola in population, but it was rapidly gaining ground. The Davis family was growing, too. By the time George Davis brought his family to the fast-rising city, two more boys had been added. Charles E., born in 1889, and Milton H., born three years later, rounded out the Davis brood.[24]

Just three years after arriving in Tampa, the Davises were witness to one of the young city's greatest spectacles: the arrival of United States soldiers on their way to Cuba and the Spanish-American War. Over thirty thousand soldiers descended on Tampa, whose population stood around fifteen thousand at the time. People were everywhere, and military campsites sprang up all over town. The *Manatee* undeniably carried an increased load of sightseers and potentially was pressed into use by a harried quartermaster corps desperately in need of quality boats and qualified boatmen. Some private citizens got rich, and legends abound that twelve-year-old Dave Davis took part in the profiteering.

One of the most enduring stories is of German-born Robert Mugge, who owned the franchise for selling Adolphus Busch's Budweiser beer on Florida's west coast. With an expected thirty thousand extra customers on the way to Tampa courtesy of the United States, Mugge ordered a trainload of beer from the main office in St. Louis. An indignant Busch wired back, informing Mugge, "There will not be a war, and we do not sell beer by the trainload." Mugge persuaded Busch to sell him the beer anyway, and he sold every drop of the amber refreshment. Davis did not have the connections or money of Mugge, but he allegedly had the same acumen. A story persists that Davis sold newspapers for the *Tampa Daily Times* during this time. Davis sold his issues earlier, faster and at a higher volume than his fellow paperboys, making a small fortune in the process.[25]

In 1899, the Davises rented a house at 406 Madison Street in downtown Tampa, which at the time was still as much neighborhood as business district. They moved the following year to another rental home at 208 Pierce Street. The three Davis boys were enrolled in school, and their father served as an

This turn-of-the-twentieth-century postcard features the pavilion at Ballast Point, located at the southern end of Tampa's Interbay Peninsula. The pavilion and nearby park offered recreational opportunities just a streetcar's ride away to Tampa's residents. *Courtesy of the Tampa Bay History Center Collection.*

engineer on a steamboat, most likely the *Manatee*. The Davises' only daughter, Elizabeth, is not listed in the census. The sixteen-year-old apparently lived away from home, possibly at a boarding or religious school.[26]

In 1901, sixteen-year-old Dave, as he was coming to be called, worked as a clerk at the law firm of Macfarlane & Raney and paid rent at his parents' Pierce Street home. Two years later, he served as a mate, probably aboard his father's steamship. He, along with his father, sister and brothers, lived in a home at 606 Jackson Street curiously listed as belonging to Elizabeth (Bessie) Davis. Around this time, probably in 1901 or 1902, Gertrude left her husband and children and returned to Jacksonville. In the parlance of the time, she had become a "grass widow." In fact, she would occasionally refer to herself as a widow and use her husband's name in the Jacksonville City Directory. In the 1920 federal census, she classified herself as a widow despite the fact that her husband, George, was alive and well—and married to another woman—in Tampa. Gertrude's departure in the early 1900s might explain her daughter Elizabeth's reappearance.[27]

By 1904, Davis gained employment with the firm of Knight & Wall, one of the largest hardware and sporting goods stores in the state. In addition, the company held the exclusive contract to sell firearms in the newly liberated nation of Cuba. A group photograph of Knight & Wall's sales staff in 1904 gives us our first look at Davis's appearance. He is an uncomfortable-looking nineteen-

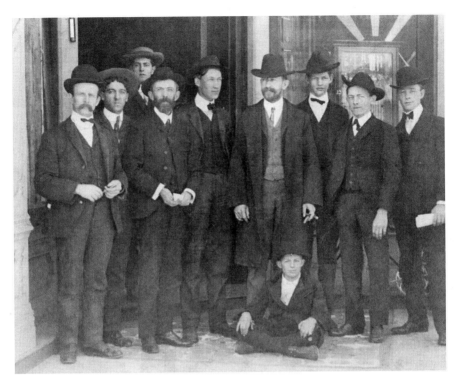

Davis, a nineteen-year-old salesman for Tampa's Knight & Wall hardware company, is pictured in this 1904 photograph with other members of the firm's sales staff. Information provided on the cabinet-card photograph identifies the men, *standing in front, from left*: Franze (Frank) Vogel, W.H.G. Scott, Jas. G. Anderson, E.H. Lester, F.M. Cooper, Budge Morse (brother of Mrs. Fred Thompson), David P. Davis and Luther Beach. The handwritten copy states, "This was the wholesale and retail salesforce of Knight and Wall Co. 1904. Mr. E.H. Lester and Mr. W.M. [*sic*] Scott were outside salesmen. Size of store at this time was 60' x 90'. These people are standing at the main entrance. Please Return Property of F.M. Cooper." *Courtesy of Tampa Bay History Center Collection.*

year-old, wearing an ill-fitting suit and misshapen hat. He is the shortest person in the photograph, except for the young boy at the bottom of the frame. Yet he still has a look of confidence, possibly even arrogance—a look seemingly inappropriate for a man of his limited means. Davis stayed at Knight & Wall until 1905 or 1906. On November 7, 1906, Elizabeth Davis, twenty-two years old, married twenty-three-year-old George Henry Hodgson, a wood dealer who lived a little more than a block away from the Davis family. The wedding took place in the newly constructed Sacred Heart Catholic Church, located in the center of Tampa's downtown. Elizabeth and George would maintain a close relationship with Dave and the rest of the Davises.[28]

In 1907, Dave partnered with Robertson T. Arnold and started the real estate firm of Davis & Arnold, located in the American National Bank Building at 616 Franklin Street in downtown Tampa. This early venture into Tampa real estate was short-lived, however, because by 1908, Davis worked as a bookkeeper at the Sanchez & Hermanos cigar factory in West Tampa. Of likely personal importance, on June 5, 1907, George Davis married for a second time. His new bride, the former Kathryn McKernon, was fifteen years younger than George. Kathryn was a teacher and had lived in Tampa since at least 1899. By 1905, she was living with her father and sister at 604 Jackson Street, right next door to the Davis family.[29]

It is possible, though improbable, that even at this early date, Davis had his mind set on developing Big and Little Grassy Islands, the small deserted keys in Hillsborough Bay. The Army Corps of Engineers enlarged a portion of Little Grassy Island to form Seddon Island in 1905. Now known as Harbour Island, Seddon Island was developed as a phosphate and lumber depot by the Seaboard Air Line railroad as a part of the city's wharf expansion and channel dredging projects. What effect that had on Davis is unknown. Certainly, however, he was aware of the geographical area and rising value of property on the west side of the Hillsborough River and the shoreline of Hillsborough Bay.[30]

Davis's historical trail becomes murky after his stint as a bookkeeper. For years, myths filled the void created by the absence of fact. Writing during the 1920s land boom and after, some authors speculated that Davis traveled to Texas or California, made a fortune in the Panama Canal Zone or sold land in Gainesville, Florida (to pay his way through the University of Florida, no less). In 1971, a reporter for the *Tampa Daily Times* asked Milton Davis to explain his brother's whereabouts for this time period. Milton responded, "I was the one who went to Panama. D.P. went to Buenos Aires [Argentina] to run a cattle business. He was there about a year."[31]

As it turns out, D.P. went to both places, but not before he made a more conventional move. By 1910, Davis was living in New York City and working in real estate. Unfortunately, it is not known exactly when or why he moved to New York. His adventurous spirit might have guided him to the bright lights of Broadway, and his charisma and sales skills would certainly have helped him find gainful, if not exciting, employment.[32]

While it is unknown when he left the United States, he is listed as a passenger aboard a New York–bound steamer that departed from Colón, Panama, on December 13, 1910. After the eight-day journey, Davis returned to the Marlborough Hotel on Broadway and Thirty-sixth Street, where he

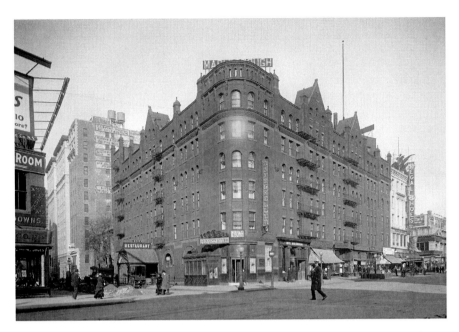

Davis spent the first portion of the 1910s in New York City. He lived for at least part of the time at the Marlborough Hotel, located on Broadway between Thirty-sixth and Thirty-seventh Streets in Manhattan. Davis likely made important contacts and learned a good deal about buying and selling real estate during his time in New York. *Courtesy of the Library of Congress.*

had been living before his trip to Panama. What he was doing in Colón is a mystery. Construction of the Panama Canal had brought vigorous life to Colón, but of all the jobs Davis held up to that point, none of them was construction related. His work in the real estate field does not offer many clues, nor does his residence in New York.[33]

The following year, 1911, he was in Buenos Aires, Argentina. Milton Davis's reason for his brother's trip to Argentina related to the cattle business, but the passenger list for the SS *Harativis* lists David as "unemployed." His field of choice was still real estate, as indicated by the occupation given in the New York City directories. Though he booked passage on a ship bound for Boston, he was still listed at the Marlborough Hotel. Perhaps the most interesting information from the 1911 passenger list is the personal information on Davis and the other passengers. The passenger list information confirms what the few extant photographs implied: D.P. Davis was fairly short. His height was listed as five feet, six inches. He had a fair complexion, dark hair and blue eyes.[34]

## DAVIS IN JACKSONVILLE

Davis left New York City and moved back to Florida, arriving in Jacksonville in late 1914 or early 1915. He lived with his mother and grandfather at his grandfather's home at 312 Duval Street in the heart of the city's bustling downtown, and as was the case in New York, he was working in real estate. His brothers Charles and Milton eventually moved to the riverside city as well, living with their mother in the Jacksonville suburb of Ortega after her father's death around 1918. Davis reappears in government records with his marriage to a twenty-four-year-old Tennessean named Marjorie H. Merritt in Jacksonville, Florida, on November 11, 1915. Apparently, Davis did not succeed in real estate because by 1916, he worked as a salesman at C.F. Cole Shoe Company. That same year, he and Marjorie welcomed their first child into the world, George Riley Davis II.[35]

The following year, Davis was an officer with the All Star Features Company. All Star Features operated a film exchange, shipping motion picture films to and from the various movie theaters in Jacksonville. The company's president, James W. Edmondson, also headed two Jacksonville-based investment companies. How the thirty-one-year-old Davis went from being a shoe salesman one year to being the vice-president of a film distribution company the next will seemingly never be known.[36]

The United States at this same time was embroiled in World War I, and Jacksonville's Camp Gordon Johnston housed thousands of soldiers preparing to fight in the trenches of France and Germany. It is often stated that Davis operated a commissary or, more to the point, a hot dog stand across from the camp's entrance. While it is possible, the story seems highly unlikely. Though probably not doling out hot dogs and Coca Cola to hungry doughboys, Davis did participate in at least one war-related event. He registered for the military draft, waiting until the final registration day to do so.[37]

Davis remained with All Star Features until 1919. Office work, or any other "regular" job, never satisfied him. If his past shows us anything, it is that he was impatient and always had an eye toward real estate. He needed a place where a man of his abilities and interests could thrive, and Jacksonville was not it. Coinciding with this, thousands of people began cascading down from the Northeast and Midwest into South Florida, in search of sunshine, orange trees and their own slice of Florida land.

Davis knew opportunity abounded with all these new arrivals. So with Marjorie and their young son, Davis headed south on the Dixie Highway to

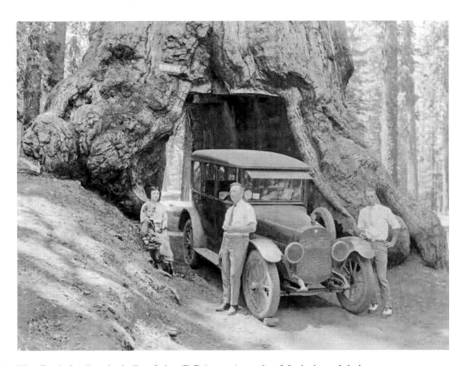

The Davis family—including father D.P. (center), mother Marjorie and their young son George—took an extended vacation to California in 1921. Two of Marjorie's aunts lived in northern California, and it stands to reason that the Davis family visited them during their time out west. Those same aunts would raise young George and his brother, D.P. Jr. after the death of their father in 1926. The man at the right is unidentified. *Courtesy of the Davis Family.*

Florida's original Magic City, Miami. By 1919, Dave, who soon went by the initials D.P., had turned his attention to South Florida's emerging real estate market. He would finally find the success in the real estate business that had long eluded him.[38]

# CHAPTER 3

# DAVIS IN MIAMI

The people of Miami found themselves in the midst of a real estate boom at the close of World War I. Several factors contributed to the astonishing growth in South Florida. The appearance of affordable automobiles and the construction of new roads revolutionized the idea of personal transportation, connecting not only the state with its neighbors but also the cities and towns within the state. This combined seamlessly with the emergence of a new American middle class that had both extra time and extra money. Florida's notoriously low land prices provided the necessary catalyst, offering an excellent opportunity for people willing to suffer through the heat and mosquitoes—two facets of tropical Florida that had not yet been conquered.[39]

Miami, before Davis and a multitude of other developers arrived, was an outpost in the wilds of South Florida. Henry Flagler's railroad brought modernization and some brave tourists to Miami with the opening of his line on April 21, 1896. The young city continued to grow through the end of the nineteenth and beginning of the twentieth centuries. The first developers of Miami properties, specifically in Miami Beach, were the Lummus brothers, John and James, followed in 1910 by John Collins and in 1912 by Carl Graham Fisher.

Fisher, who is almost synonymous with the Florida boom in Miami, also constructed the Dixie Highway, linking South Florida with the large population centers of the Midwest and Northeast. Davis praised the pioneering developer in 1924, telling the *Tampa Morning Tribune* that "Miami did not begin to make

its magic strides until Carl Fisher had bought Miami Beach, a stretch of dreary sandland, and converted it into a fairyland of beauty."[40]

By 1920, tourists and immigrants were pouring into Miami and South Florida. Well-built roads, the benefit of a new state road department and the Federal Road Aid Act, carried Florida's growing populace more efficiently and in far more directions than the railroad ever could. Miami's population almost doubled between 1913 and 1919. The Lummus brothers, with Collins and Thomas Pancoast, started a streetcar line between Miami and Miami Beach in 1919, facilitating access to the respective cities and providing a leisurely sightseeing tour, as well. Another innovation in Miami was the creation of Binder Boys. Noted by their quick cadence and snappy attire (collectively, they kept the golf knickers industry in business through the 1920s), they would purchase lots with a thirty-day binder, or contract, for 10 percent of the total cost. That binder could be sold and resold, rising in value each time. At the end of the thirty days, the person in possession of that contract was bound by law to honor it, which meant that they had to begin paying off the balance due. Historian William Rogers notes that "at one time Miami had 25,000 such street brokers." By their sheer numbers, they contributed greatly to Miami's meteoric population increase.[41]

Davis was not in the early group of land speculators, but he did watch and learn from them. He noted what worked and what did not. While others laid the foundation, Davis applied his own abilities and went to work building his own corner of paradise—which he would subdivide and make available for 10 percent down. Like most every aspect of his life, the story of how Davis first started selling real estate in Miami may be more parable than history. The basic story, as told by the *Atlanta Constitution* in May 1921, began, "There are other ways of getting a fortune other than by inheriting it, or 'being born with a silver spoon in your mouth.' The present case deals with D.P. Davis, of Miami, Fla., known as 'Florida's youngest thing less than $5,000 in hard cash millionaire.'" The newspaper estimated Davis's wealth at the time at $1 million and said that he earned it by buying land, dividing it, selling it and then reinvesting the profits in buying more land. He was finally able to purchase "an immense tract of land" to develop. Other stories say specifically that Davis came across a development that had been "languishing" on the market. While not in the most advantageous location, with a little perseverance and a lot of advertising, Davis sold every available lot within days, making a tidy profit for his efforts.[42]

While there is undoubtedly some truth to the story, Davis's publicity machine, which went into overdrive after 1924, probably enhanced the

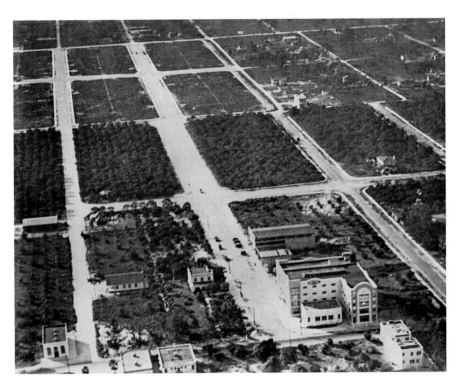

This aerial view of Davis's Commercial Biltmore subdivision in Miami clearly shows the Moore Furniture Building in the right foreground and the intersection of Fortieth Street and Second Avenue Northeast (Biscayne Boulevard), circa 1921. *Courtesy of the Florida State Archives.*

original details. Davis did begin selling land that was thought too difficult to sell because it sat two and a half miles from the city center. He then opened his own company, United Realty, and started his first development, a business district dubbed Commercial Biltmore. This property lay in the greater Buena Vista subdivision, located just north of Miami's city limits. Buena Vista, or at least a section of it, is likely the fabled "languishing" property. Regardless, Davis made Commercial Biltmore a success with the same qualities attributed to him in both fact and fiction. He knew the importance of advertising, but more importantly, he understood the benefit of providing complete infrastructure with his subdivisions. For Commercial Biltmore, that infrastructure included wide streets, curbing, sidewalks, water and sewer service and lush landscaping. The business district included stores—most notably Moore Furniture Company—a theater and business offices. Davis did not use the Mediterranean Revival

style of architecture that later would become synonymous with the Florida boom. Instead, his architects used a local vernacular style, building mostly bungalows in the residential areas with Colonial and Federal influences found in the commercial sections.[43]

Before Commercial Biltmore neared completion, Davis began developing the adjacent property into a residential section appropriately called Biltmore. The architectural styles within Biltmore reflected those of his neighboring development, and the homes were mostly bungalows, which were widely popular and relatively inexpensive to build. As with all his properties, past, present and future, Davis followed the axiom "location, location, location." In reflecting on his Miami properties, Davis said that he always tried to chose "the most strategically located property in big and growing population centers," then focus on the "improvements," streets, landscaping or light poles and the buildings themselves.[44]

In addition to Commercial Biltmore and residential Biltmore, Davis started sales on another residential project in the greater Buena Vista section, Shadowlawn. Located within the former Broadmoor subdivision, Shadowlawn boasted features that were becoming ubiquitous—wide, curbed streets, spacious sidewalks and an abundance of tropical plants. Shadow Drive, the neighborhood's main thoroughfare, featured a stone-faced set of entry columns, providing an air of class and individuality to an otherwise ordinary subdivision.[45]

The two Biltmores quickly neared completion at the close of 1921. Families and businesses began moving in to the newly constructed edifices, and some, such as the Moore Furniture Company, hosted elaborate grand opening celebrations. In addition, many empty lots were still being sold back and forth between a growing cadre of land speculators. Though Davis undoubtedly participated in this fervent resale market, United Realty declared that every lot in all three developments was sold out, at an average cost of $2,500.[46]

The Miami papers were filled with two very different types of stories throughout January 1922. While Hollywood funny man turned outcast Roscoe "Fatty" Arbuckle endured his retrial on career-ending rape, drug and murder charges, Davis prepared for a media blitz that would further boost the developer's career. The fortunes of the two men, both in their midthirties, were going in completely opposite directions. Print ads for United Realty's newest subdivision, unimaginatively titled Shadowlawn Extension, began running on January 11, 1922. The first ad covered the two center pages of the *Herald*. Davis touted his previous successes, promising that Shadowlawn

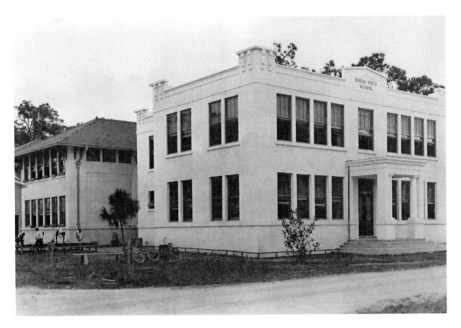

Davis wanted people to actually live in his subdivisions rather than just buy and sell the land. He paid attention to detail, from the landscaping and sidewalks to the overall layout and nearby amenities. School buildings were part of his plans for both the Buena Vista and Shadowlawn subdivisions in Miami. *Courtesy of the Florida State Archives.*

Extension would bring the same results. He included photographic proof of the progress of his earlier projects, featuring all thirty-five completed structures within the developments.[47]

The same day that United Realty placed the two-page advertisement, the *Herald* printed an anonymous "news" article featuring Davis and his new development. This was a fairly common ploy used by savvy developers at the time. The first sentence of the story was just a tease for the "most unusual advertisement on the two center pages of this morning's edition." The story quoted only one source, United Realty's publicist J.A. Riach, who probably wrote the piece himself. Riach speaks in reverence about Davis and "the thorough going manner in which [he] does his development work. He bothers more about the quality of the work than he does about the cost." The pitchman then compliments the City of Miami and the *Herald*, relating the story about how United Realty did not need to go out of town to Jacksonville or Savannah for graphics work. Instead, "Right here in Miami in the *Miami Herald* office, it was all turned out for us." The story closes with a final quote from Riach:

*It is to my mind fortunate for Miami that a man of the type of Mr. Davis, happened to take the helm in the development of such an important section as he has in the composite properties. The phenomenal success he has had is the natural result to be expected of such a comprehensive program.*[48]

Another tactic to gain the public's trust was the use of an independent, professional organization to lend an air of legitimacy to a particular project. Just four days prior to Davis's mass marketing, the Miami Realty Board placed an ad of its own in the *Herald*. The board warned the real estate–buying public about "unscrupulous hucksters and real estate conmen" who preyed on unwitting buyers throughout Miami. In response, the realty board printed a code of ethics and assured the public that all the members adhered to these rules or faced expulsion from the organization. The code, among other things, forbade "sensational and unethical methods of selling and advertising Miami real estate" and railed against "the molestation of Miami citizens and visitors on the streets, sidewalks and street corners" by these knickers-clad shysters.[49]

It is impossible to know whether Davis influenced the timing of this advertisement and similar ones placed by the Miami Realty Board in the months of January and February. At the very least, he took notice and made sure to include the "Member, Miami Realty Board" seal on all four corners of every ad he placed for Shadowlawn Extension. Davis peppered the *Herald* on a daily basis with ad copy, maintaining either a full- or half-page advertisement for his latest development from January 11 through February 20. Each one had subtle variations, focusing on a different point or targeting a different demographic.[50]

One of the most common strategies used during the month-long barrage were references to his other projects, which of course were in "close proximity" to the new venture. Davis also repeatedly mentioned how close Shadowlawn Extension was to the Buena Vista terminus of Miami's streetcar system (a three-minute walk) and how his company would take reservations for the day that sales would begin, January 18. Among the promises was a seventy-five-foot-wide avenue intersecting Biscayne Boulevard, leading to the new neighborhood and, of course, fantastic profits to the investor wise enough to buy early. The advertising reached its zenith on January 18, with the second straight day of full-page ads. Buyers had been advised for the past week that, unlike most of Miami's land sales, the sale of Shadowlawn Extension would not be an auction. The lots had a fixed price of $1,500, first come, first served. Davis's ad closed with the ominous admonition, "Do it now—Tomorrow will never arrive."[51]

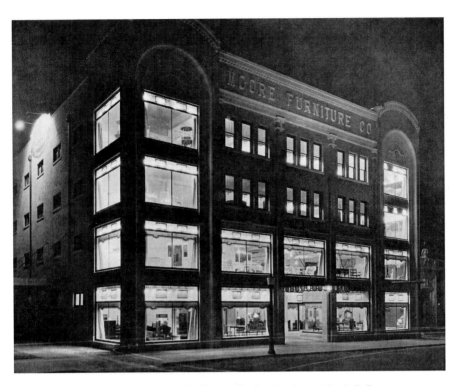

The Moore Furniture Company was built near the intersection of Fortieth Street and Second Avenue Northeast (Biscayne Boulevard) in the business district of Davis's Commercial Biltmore subdivision. This photograph was likely taken in 1921. *Courtesy of the Florida State Archives Collection.*

Despite the apocalyptic warning, tomorrow did arrive, bringing with it news of another United Realty success. As with the announcement of land sales on the eleventh, the January 19 edition of the *Herald* featured an unattributed article relating the news of Davis and his development. The headline touted, "Davis Subdivision Opening Sale Big," and the story went into detail about the development and the people who bought there. The subhead spoke of "Home People," or locals, who were the main buyers of lots. This theme was continuously repeated in United Realty ads. Unlike the previous article, Davis himself was quoted in the January 19 piece. He, too, was impressed with the number of Miamians who purchased lots in his subdivision, stating:

> *A significant fact is that the folks who bought our lots are all home folks. It makes me feel gratified that those who have been here, and are Miamians,*

*and who ought to know values, have come out to buy where they are getting
value for their money.*[52]

Davis and United Realty placed advertisements, usually one-half or
one-third of a page in size, in the *Herald* through the entire sales period
of Shadowlawn Extension, which concluded on February 20. These ads
exhorted those who had yet to buy to go out and see the project, assuring
them that once they did so they would snap up a lot or two. The ads also
relayed a reassuring tone, speaking of the profits on resale and on the
value of Shadowlawn Extension as an investment—perhaps even for "your
fourteen-year-old" who, when he turns twenty-one, will "have a lot of his
own." Davis's efforts paid off, and Shadowlawn Extension, like his earlier
investments, was an unqualified success.[53]

The year 1922, while providing a financial windfall for Davis, also took
away something very dear. His wife, Marjorie, died a few weeks after
giving birth to their second child, a boy named David Paul Davis Jr. It
is unimaginable how Davis, at the peak of his professional life, felt as his
personal life seemed to fall apart. Though the cause of Marjorie's death was
tied to the birth of their child, the baby survived the ordeal, and Davis pulled
himself together and finished his real estate projects. He did not do it alone.
He asked his younger brother, Milton, along with Milton's wife, Louise, to
come to Miami and help him with his developments and, probably, with
his wounded family. Milton went to Miami, and though he worked for a
different company, Fidelity Realty, his and D.P.'s offices were less than a half-
mile apart. They spent 1923 working on D.P. Davis's projects, which would
grow to include the Alta Vista and Bellaire subdivisions.[54]

After his wife's death, Davis began to indulge in the excesses that marked
the Jazz Age. Defying Prohibition, a Davis hallmark, was a core tenet of the
era. He also began seeing a young woman named Lucille Zehring, one of
movie producer Mack Sennett's "Bathing Beauties." Another product of the
freewheeling Twenties, Zehring would play a very pivotal role in Davis's future.[55]

Davis had to realize that despite his accomplishments in Miami, he could
not compete with developments such as Fisher's Miami Beach or George
Merrick's Coral Gables, or for that matter, Addison Mizner's Palm Beach.
Once again, Davis began to look elsewhere for new opportunities. He
decided to return to Tampa, which itself was caught up in Florida's land
boom. In addition, with the exception of Milton who was in Miami, Davis's
immediate family lived in the bustling west coast city, and he could rely on
them to help care for his two young boys.

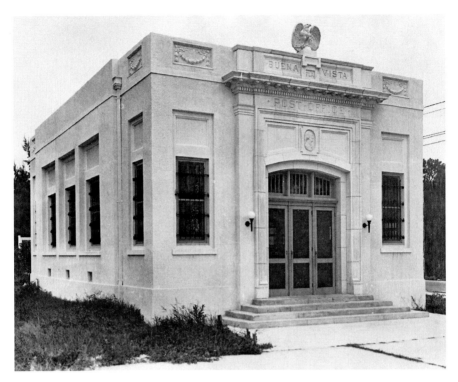

The imposing and ornate Buena Vista Post Office, circa 1922. Davis built a variety of public buildings in his developments throughout his career. The Buena Vista Post Office is still standing and is now a restaurant in Miami's fashionable Design District. *Courtesy of the Florida State Archives.*

Perhaps as important, Davis knew of the possibilities that Tampa held. Transportation by rail, ship, automobile or even airplane fostered a growth on par with that of Miami. Davis felt that Tampa, unlike Miami, would cater to both a vacation market and a business market, meaning more year-round residents and, consequentially, a greater need for quality housing near the city's business center. Unfortunately, all the prime real estate had long been sold and developed—at least that which was above sea level. Davis heard of a plan that would change the City of Tampa forever. Burks E. Hamner, a local real estate promoter, had conceived of the idea of developing the mud flats in Hillsborough Bay in 1921. Hamner was likely too busy at the time working on Temple Terraces, a subdivision named for the Temple orange, to devote any energy toward this new idea. Located north of Tampa in what is now the city of Temple Terrace, the development catered to the "weekend farmer" who could leave the city to a restful, Mediterranean Revival–style

home amid the orange groves. The island development would share Temple Terrace's architecture but not its lifestyle. Hamner likely contacted Davis in late 1922 or early 1923 about beginning what would become Davis Islands. During a Tampa Rotary Club lunch in early 1923, Hamner described "in minute detail" his idea for an island development. Club members, at the time, claimed he had a "vivid imagination." [56]

Davis and his two boys departed Miami in January 1924, almost exactly four years after their arrival. Undeniably changed by his wife's death, Davis also left behind six thriving communities and, in a more practical move, retained his Miami business office which he renamed D.P. Davis, Inc.[57]

## COCOA INTERLUDE

Real estate developers scoured Florida during the 1920s land boom. Pitchmen covered the state, focusing mainly on the still largely untapped coastal lands for which Florida is now famous. One such area was the city of Cocoa, about two hundred miles due north of Miami. Beginning in late 1923, Davis started to gain an interest in Cocoa, specifically a development known as Carleton Terrace. The Cocoa of Davis's time was a small city, with a population of around 1,500. The city was incorporated in 1895, but the area was first settled just before the Civil War. Nestled along the Indian River, Cocoa was in the middle of one of the best orange-growing regions in the state, with some groves dating from the 1860s. As such, Cocoa served as a center for citrus shipments on Florida's east coast.

Word of Davis's involvement in a local real estate development was front-page news in the December 13, 1923 edition of the *Cocoa Tribune*. The main headline read, "Big Development is Started in North Cocoa, Carlton Terrace Name," with the subhead stating, "D.P. Davis of Miami Purchases Large Waterfront Tract for Highest Class Residential Section." The article reads like most from that time and lists Davis's accomplishments in Miami and his plans for Cocoa. The article also mentions that Milton Davis, D.P.'s brother, would be a partner in the endeavor and that D.P.'s company, United Realty, had already purchased one hundred acres of land for the new development.[58]

Carleton Terrace was designed and put to paper in March 1924 by the Miami engineering firm of Watson & Garris. The plat, filed in Brevard County the following month, on April 21, featured the hallmarks associated

with Davis and other high-class developers of the period: broad, well-landscaped streets with exotic names situated close to a body of water. A small development, the neighborhood consisted of only fourteen streets, including the Dixie Highway (US 1), which ran north–south through the eastern portion of the subdivision. Davis partnered with a local firm, Trafford Realty Company, on this project. A.R. Trafford, according to the *Cocoa Tribune*, had been working for over a year to get Davis to go to Cocoa and partner with him on the project. After the initial meetings and interviews, the main weight of the project would be borne by Milton Davis, not his older brother—D.P. had a much larger project in mind in 1924.[59]

Carleton Terrace serves as an interesting bridge between Davis's work in Miami and Davis Islands. The streets in Carleton Terrace are not on a grid but, instead, are curved or run at odd angles. Another characteristic of the development, its streets' names, demonstrates that Davis was at least partially involved in the development. The names Biltmore, Bellaire and Dade reflect his past experiences in Miami, as does Lucerne, a street name Carleton Terrace shares with Miami Beach and Davis Islands in Tampa. Another shared feature of the Davis developments in Miami, Cocoa and Tampa was Miami architect Martin Hampton, who designed homes for Davis's projects in all three cities.[60]

By 1925, D.P. was far too busy to spend much time with Carleton Terrace. Milton, too, was pressed into service for both Davis Islands and Davis Shores in St. Augustine, thereby decreasing his time spent with Carleton Terrace. Still, work progressed in Cocoa, with over eighty homes completed between 1924 and 1926. Today, the neighborhood carries the same layout, and with few exceptions, the streets retain their original names. Additionally, twenty-two homes dating from the heady days of Florida's boom are still standing, another testament to the life of D.P. Davis.[61]

CHAPTER 4

# DAVIS FAMILY REMAINS
# IN TAMPA

While Davis moved to New York, then Jacksonville and finally Miami, his family remained in Tampa. By 1913, George and Kathryn Davis owned a home, located at 207 South Boulevard in the Hyde Park neighborhood. David's brothers, as well as other families, would occasionally rent rooms in the Davis house. The mud flats that would become Davis Islands could be seen from the roof of the South Boulevard home.[62]

Tampa, like Miami to the south, experienced a building and population boom following World War I. The west coast city climbed past all except Jacksonville in the state's 1920 census rankings, propelled by the cigar industry and valuable wartime shipbuilding contracts. Tampa's corporate limits expanded in 1923 with the annexation of most of the land south and east of the Hillsborough River to Fortieth Street, including the Seminole Heights, south Sulphur Springs and Gary neighborhoods, in addition to the submerged lands south of the little islands in Hillsborough Bay—a move that would be important to Davis the following year. By the time Davis returned in 1924, Tampa boasted a greater metropolitan area population of over 124,000 people, and the cigar industry, still the city's largest employer, produced half a billion cigars annually—all made by hand. Tampa rightly laid claim to the title "Cigar Capital of the World." Tampa's statistics would grow even bigger in 1925 with the annexation of the city of West Tampa, a cigar-making enclave located west of the Hillsborough River. Davis's new creation in Hillsborough Bay, Davis Islands, would also add land area, people and money to the Tampa economy.[63]

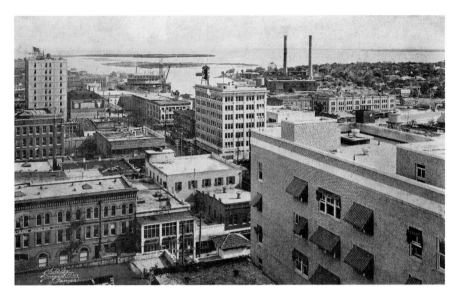

This aerial photograph, taken over downtown Tampa around 1920, shows the view looking south over Hillsborough Bay. Little Grassy and Big Grassy Islands, the foundation for Davis Islands, are clearly visible at the mouth of the Hillsborough River. *Courtesy of the Tampa Bay History Center Collection.*

# BEFORE THEY WERE "THE ISLANDS"

The two islands Davis used as the nucleus for his development had been known by a variety of names throughout Tampa's history. They first appeared, nameless, on seventeenth-century Spanish maps that were detailed enough to show modern-day Tampa and Hillsborough Bays. The islands were included as part of the Fort Brooke military reservation created in 1824, and it was probably during the fort years that the larger of the two islands picked up its first name, Depot Key. Various other names, all describing a particular feature of the islands, appeared through the years, including Rabbit Island, Big and Little Islands, Grassy Islands and, eventually, Big Grassy and Little Grassy Islands.[64]

The first recorded sale of either bay island came on April 18, 1860, when William Whitaker purchased the southern tip of Depot Key (Big Grassy Island), a total of six and one-third acres, for one dollar per acre. Little Grassy Island and the remainder of Depot Key were purchased in 1881. W.C. Brown purchased the entire sixteen-and-one-third-acre Little Grassy

Island for the same price per acre as Whitaker had paid twenty-one years before. Brown and William B. Henderson teamed up to purchase a large portion (sixty-nine and three-quarters acres) of Big Grassy Island from the state for ninety cents per acre. The remainder of the island, twenty-eight and one-half acres, was purchased by the Town of Tampa at the same price. Brown and Henderson, in turn, obtained a ninety-nine-year lease for the town's portion for twenty dollars a year.[65]

During one of the first channel dredging projects of the 1880s, cypress tree stumps were discovered in eight feet of water a few yards south of Big Grassy Island, illustrating that the whole bay used to be above sea level during the last ice age. Another channel dredging project, begun in the early 1900s, bisected Little Grassy Island, creating Seddon Island on the east side of the channel and a remnant of Little Grassy Island on the west side. Little Grassy Island usually disappeared under a strong high tide, but Big Grassy Island generally remained dry. Both islands were completely covered by water during the 1921 hurricane.[66]

Tampa's City Council, on June 8, 1920, offered a referendum to voters asking whether they would support the purchase of Little Grassy Island for use as a city park. In an incredibly tight vote, the referendum passed 694-692. Though nonbinding, the city agreed with the majority and purchased Little Grassy Island from Mary E. Brown, widow of W.C. Brown, on May 9, 1921, for $25,000.[67]

Many histories of Tampa and Davis Islands relate stories of Boy Scout Troops going out to the bay islands for camp outs. Davis and his brothers, according to Milton, also ventured out onto the scrub-covered mud flats, catching crabs and frying fish instead of attending school.[68]

# A REVOLUTIONARY DEVELOPMENT

Davis had bigger fish to fry when he returned to Tampa in January 1924. He intended to put Hamner's bay island plan into motion, but a variety of obstacles faced him before this could be accomplished. Davis first needed to meet with the city's leadership, both political and financial, to ensure the islands investment was a viable and legal proposition. Tampa's mayor and city commission readily endorsed the plan, as did the board of trade, the city's major business organization, and Peter O. Knight, the city's most powerful and well-connected business and civic leader.[69]

# TAMPA —A City of Opportunity!

The eyes of the nation are focused on Tampa. Wherever you go you will hear of Tampa's awakening, that it is the fastest growing city in the South, that its real estate values are the greatest and soundest in Florida, that it will smash all building records the same as it recently smashed the world's record for real estate buying and selling. Success a-plenty will be attained here, fortunes a-many will be made here—not in a long term of years but within a time that practically reduces itself to months! Right now there are Tampa people, although they may not realize it today, who are "fixed" for life through their recent purchase of property.

———at———

# DAVIS ISLANDS
### Tampa in the Bay

*Florida's $30,000,000 Island-Home Development*

# D. P. DAVIS PROPERTIES

Franklin Street at Madison  :  :  :  TAMPA

Davis was a master at marketing his projects, and the advertising he ran for Davis Islands showed him at his best. While some ads were almost all imagery, others were entirely text. Though probably anachronistic today, ads like this were very effective during their time. *Courtesy of the Tampa Bay History Center Collection.*

The next step centered on land acquisition, including a contract with the city that would authorize the sale of Little Grassy Island plus its share in Big Grassy Island to him and allow him to fill in the submerged lands surrounding them. Negotiations between Davis—represented by Giddings Mabry from the prominent Tampa law firm Mabry, Reaves and Carlton—and the city were surprisingly public, with the *Tampa Morning Tribune* covering their progress on an almost daily basis. The two parties quickly came to terms, with approval by the city commission the final hurdle. Some public opposition did exist. A small but wealthy and influential group of residents who lived on or near Bayshore Boulevard objected to Davis's plans because it would be detrimental to their view of Hillsborough Bay. These residents, led by Dr. Louis A. Bize, who in addition to his medical practice also served as president of Citizens Bank and Trust, outlined their problems in a letter sent to Tampa City Commissioners on February 12, 1924. The Bayshore residents' view corridor was not the end of their problems with the Davis project. Their letter outlined six points of "protest" to the city commission. The first four stated that the city had no right under Florida law to sell the riparian (underwater) rights to Davis, or any other developer, for the purpose of filling in. The fifth point served as an appeal to the environmentalists on the commission (there were none), explaining that the development "would be a spoilation of a great portion of Hillsboro [sic] Bay, the greatest natural attraction in the vicinity of said city." They ended with a general attack on the contract itself, which Bize and his neighbors saw as "vague, uncertain, indefinite, and fails to provide limitations against additional encroachments upon the lands held in trust by the City of Tampa and the State of Florida."[70]

Though submitted by eight people, the neighborhood contingent kept their protest to one page. In contrast, Karl Whitaker, powerful local lawyer and future city attorney, wrote a twelve-page epistle, attacking the proposed contract point by point. Whitaker began by explaining that he did not "care at this time to enter into a discussion as to the merits or demerits of the so called Davis Development Project." Whitaker then outlined what he would like to see happen to Little Grassy Islands, a park similar to one in Miami's Biscayne Bay.[71]

He continued to dissect the draft agreement. His comments ranged from the legalities and limits of the project to the wording of certain parts of the contract to the size and dimensions of planned city park space to the small number of limitations placed on Davis and his development. While the city did adopt some of Whitaker's suggestions in this regard, such as the prohibition

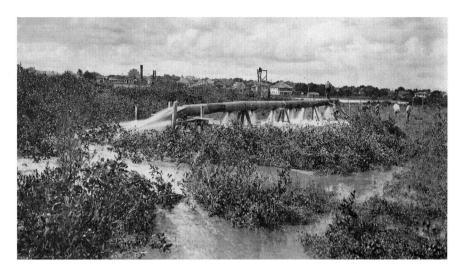

Millions of cubic feet of sand had to be pumped from the bottom of Hillsborough Bay before Davis Islands could become a reality. Dredges worked night and day to accomplish this feat, but it still took close to four years before the job was finally complete. *Courtesy of the Tampa Bay History Center Collection.*

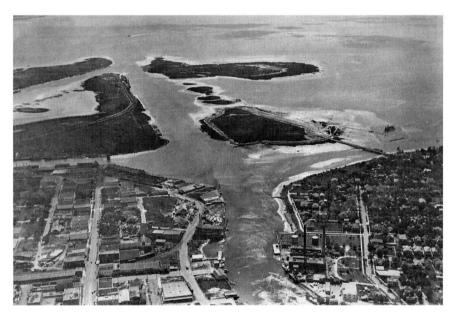

Progress is clearly seen in this aerial photograph of Davis Islands, taken sometime in the middle of 1925. There is still quite a bit of work to do, and dredges would work night and day to pump millions of tons of sand up from the bay to fill in the seawalls that were constructed around the perimeter of the new island development. *Courtesy of the Tampa Bay History Center Collection.*

of "railroad terminals," it did not include a covenant restricting "persons of African descent" from buying property within the Davis Islands neighborhood. The appearance of such a covenant would not have been unusual, as there were other developments in Tampa and around the country that included them, but it was not expressly detailed in the final contract.[72]

A number of people and organizations supported Davis's proposed island development. As previously mentioned, the board of trade strongly backed the idea, as did the Optimist Club of Tampa and numerous other business people, especially real estate agents and builders. Even Bize warmed to the prospect of the islands development.[73]

While wrangling with the city and citizenship over his proposed contract and development, Davis also went about the task of purchasing the nonpublic portions of Big Grassy Island from the estates of the Brown, Henderson and Whitaker families. Davis and his attorney negotiated the purchase of the Brown and Henderson portion of Big Grassy Island for $100,000, or $1,433.69 an acre. He was not as fortunate in his dealing with the Whitaker Estate, of which Karl Whitaker was an important part. Davis finally purchased the six and one-third acres of Big Grassy Island for $50,000—$7,936.50 an acre. Following the mantra of the times, if Whitaker could not stop progress, he would at least profit from it.[74]

City commissioners signed the completed contract with Davis on February 26, 1924. The contract, altered slightly through the efforts of both Bize and Whitaker, still heavily favored Davis. It began with the sale of the city's rights to Little Grassy Island, its share of Big Grassy Island and all of the surrounding submerged land for $200,000.[75]

Restrictive covenants occupied the second section of the contract. Included among them were no "manufacturing plants, wholesale purposes shipyards; steam-railways or railway terminals, or commercial docks or wharves." The city also forbade "buildings or structures" or "any fill...west of the west boundary of said property." No mention appears of any other boundary restrictions, one of Whitaker's major issues. While it remains unclear why the contract was written in this manner, Davis did not exceed any of the boundaries of the original sale.[76]

The project was described in the contract as a "high-class residential subdivision," which included a bridge to the development and parks within it. Both would be deeded to the city under the parameters of the contract.[77]

The $200,000 Davis paid for the islands came as a surety bond, which would be returned to him in stages. The city would release $100,000 "if and when the said bridge shall be constructed and the seawall and fills herein

provided for shall be fifty percent complete, the city may accept a deed to the said bridge and fifty-five (55) acres of parks." Davis would receive the rest when "said seawalls and fills herein provided for shall be completed."[78]

City code stipulated that a contract of this scope must be ratified by the citizenship within ninety days, so a referendum was set for April 22. The voting public overwhelmingly approved the contract, with 1,313 voting for and 50 voting against. A review of the details behind the $200,000 surety bond Davis placed with the city allows an interesting look into the 1920s Florida land boom. Davis did not use his own money but instead had investors—including two sitting Tampa City commissioners, William A. Adams and William J. Barritt—purchase bonds of varying amounts, totaling $225,281.25. A wide variety of people held these bonds, and the bonds themselves held a range of values. A total of eighty-two people, from business owners to window dressers, attorneys to teachers, real estate men to physicians, laid their money down, apparently convinced of the Davis project's success. Investments, in the form of promissory notes, ranged from $1,875 to $5,000. No consistent pattern exists connecting the eighty-two investors, though they are possibly linked through the board of trade. Another probable connection is Peter O. Knight, who was an owner or investor in a number of the businesses represented in the tally of note signers. Both city commissioners invested toward the end of the process, placing their money in after the required $200,000 mark had been met. While there are records of money exchanges from 1924 to 1926, there is no evidence that any of these notes were returned or discontinued when the Davis contract was finally fulfilled in 1928.[79]

A section of Davis's contract with the city stipulated that he had the "right to acquire, at his own expense a judicial determination of the City's right to grant to him the rights herein set forth." His attorneys brought the issue through the court system to the State Supreme Court, which ruled on September 9, 1924, that the city did have the right to sell not only land but also the submerged areas around that land.[80]

While Davis's legal case wound its way through Florida's court system, work began on lining up the necessary contractors to bring Davis and Hamner's dream to life. Davis signed a $2-million contract with Northern Dredge and Dock Company to pump nine million cubic yards of sand from the bottom of Hillsborough Bay onto Big and Little Grassy Islands, creating Davis Islands. While he promised the city an expensive permanent bridge to the development, he needed a quick and cheap temporary bridge just to get men, machines, mules and materials to the site. The temporary bridge opened November 8, 1924, thirty-five days after land sales began for

A group of local politicians, prominent businessmen and D.P. Davis Properties associates pose for a photo aboard a ferry during a trip to view construction on Davis Islands. Davis appears in the center of the back row. *Courtesy of the Tampa Bay History Center Collection.*

Davis Islands. The following day's *Morning Tribune* featured a photograph of Davis's business partner, A.Y. Milam, with two-year-old David P. Davis Jr. in his arms, the first people to drive onto Davis Islands. Within days after completion of the temporary bridge, photographers and sightseers joined the construction crews on the ever-growing property.[81]

When Davis announced details of his plan to build "Florida's Supreme $30,000,000 Development," the response from prospective buyers was overwhelming. Davis used the experience he gained in Miami and applied it well to the new Tampa venture. He opened a sales office in a very prominent downtown location, 502 North Franklin Street. One of the legends of the time relates that Davis chose this site because it previously housed a candy store known as Drowdy's Corner—the windows of which he wantonly stared into as a boy.[82]

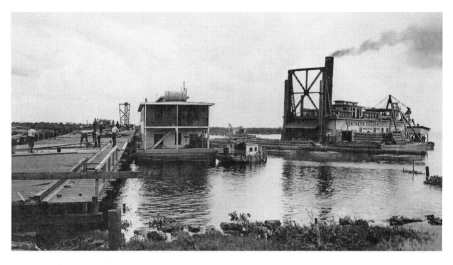

Construction of the temporary bridge was among the most important early activities on Davis Islands. Ferries and barges brought workers and equipment to the job site, but the opening of the bridge meant a steady and reliable flow of those necessities, plus interested buyers. *Courtesy of the Tampa Bay History Center Collection.*

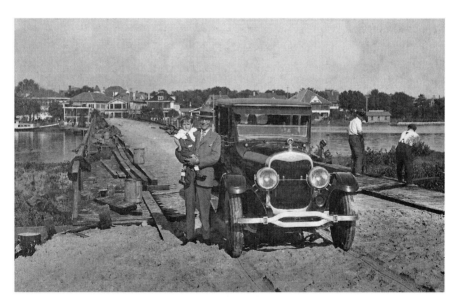

D.P. Davis Jr. was just over two years old when this photo was taken with him in the arms of Arthur Y. Milam, vice-president of D.P. Davis Properties. Milam and Davis were reported to be the first to drive over the temporary bridge after its completion in late 1924. *Courtesy of the Tampa Bay History Center Collection.*

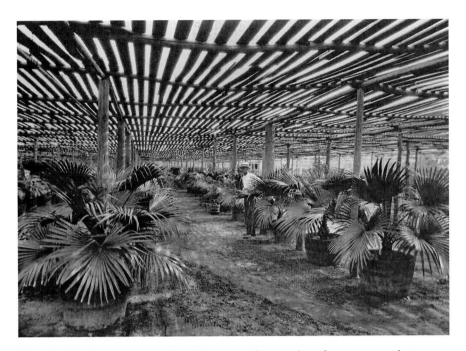

Since the island project was starting with pure sand, every plant, from grass to palm trees, had to be brought onto the property. An entire nursery was established on the outskirts of Tampa to grow the necessary plants for Davis Islands. Many of the palm trees that line Davis Boulevard are the original specimens that were planted in 1925. *Courtesy of the Tampa Bay History Center Collection.*

The sales office was awash in plans, schematics and propaganda detailing the future look, feel and functions of Davis Islands. A forty- by twenty-foot three-dimensional model of the project, designed and constructed by noted artist Harry Bierce and his staff, filled the center of the office. The model, like most everything else Davis did, was billed as "the world's largest." The Davis Islands development would encompass three separate islands and would be a city within itself, created for the new America booming all around. Built with both the automobile and pedestrian in mind, plans for Davis Islands called for wide, curving streets, and the main thoroughfare, Davis Boulevard, would have roomy sidewalks running along both sides. Landscape design responsibilities were given to Frank Button, a widely respected and nationally recognized landscape architect.[83]

Residential properties took a variety of forms. While single-family homes dominated the drafting boards of the islands' architects, other housing options existed for seasonal and year-round residents. These multifamily residences,

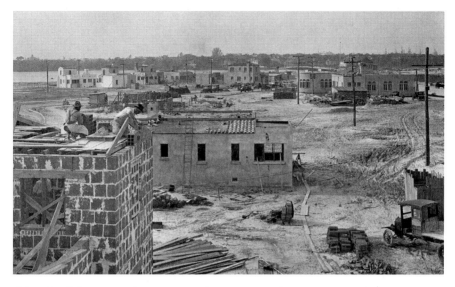

Other than infrastructure improvements, home construction was the single largest investment in time and materials on Davis Islands. Close to one hundred homes were completed between 1925 and 1929, and though they shared many design features, they also carried distinctive elements. *Courtesy of the Tampa Bay History Center Collection.*

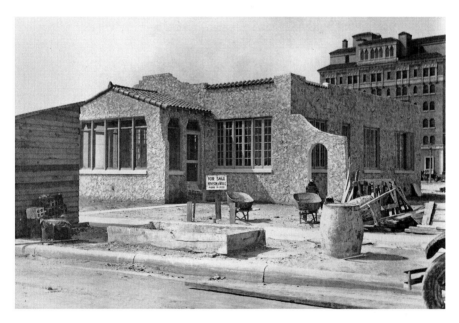

This home, one of the smaller featured on the islands, was one of many built on the northern portion of Davis Islands in 1925. The Mirasol Hotel appears across Davis Boulevard in the background. *Courtesy of the Tampa Bay History Center Collection.*

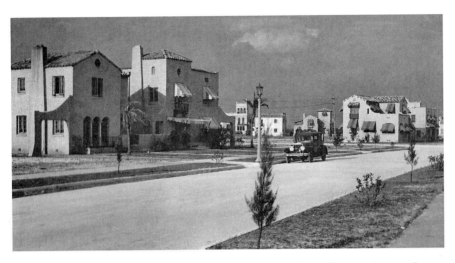

The streets on Davis Islands follow a roughly alphabetical ordering from north to south. Consequently, the oldest homes are along the A, B and C Streets. These homes are along Adriatic. *Courtesy of the Tampa Bay History Center Collection.*

both apartments and hotels, were restricted to Davis Boulevard and a few streets close to that central corridor. All structures built on the islands would follow design guidelines established by Davis's company, D.P. Davis Properties. These rules, though greatly relaxed, would last until 1956.[84]

Davis designed the islands' development so that it widened from north (closest to the mainland) to south. Davis Boulevard splits into East and West Davis Boulevards, which reunite at the bottom of the islands to form South Davis Boulevard. West and South Davis Boulevards were reserved exclusively for homes while East Davis was predominantly apartments, hotels and the business district. The streets winding through Davis Islands carry a themed naming system. To further immerse residents and visitors into the islands' scheme, all right of ways, except Davis Boulevard, were named after magical and exotic-sounding islands or bodies of water, such as Aegean, Jamaica and Ceylon. They would also follow a loose alphabetical pattern, from north to south (Adalia to Susquehanna), with none more than five hundred yards from the water.[85]

Relaxation and athletics were other important facets of the Davis Islands Plan. Tennis courts and a nine-hole golf course, each with its own clubhouse, covered a considerable portion of the islands. The tennis courts were situated within the fifty-five-acre city park, which Davis named Marjorie Park in honor of his deceased wife. A Roman Pool and Yacht Basin rounded out the proposed Davis Islands recreational landscape.[86]

CHAPTER 5

# DAVIS ISLANDS
# BECOMES REALITY

D avis launched, in the summer of 1924, a sales campaign unparalleled
in the area's history. He continuously touted Davis Islands in half-
and full-page newspaper advertisements in Tampa's morning and evening
papers, similarly sized ads in a host of other Florida newspapers and
advertisements in guidebooks and magazines targeting the growing tourist
market. The term "mass media" had just entered the national lexicon in
1923, and Davis understood its power. He bought time on Tampa's flagship
radio station, WDAE, and ensured his ads found their way into all manner
of Tampa tourism and promotional publications. He also sponsored, in
1926, publication of Kenneth Roberts's *Florida*, a history of the state.[87]

Another step toward making Davis Islands a reality was the formation of
D.P. Davis Properties, Inc. Davis knew the importance of connecting with
the right people. In Tampa, that meant Peter O. Knight. In Florida, it meant
Arthur Y. Milam. When Davis incorporated his new investment company,
he placed Milam in the vice-president's chair. Milam, a Jacksonville attorney,
had entered Florida's House of Representatives the previous year and
would, in 1925, assume the position of Speaker of the House. Milam held
both political and financial power and, with his brother and law partner
Robert Richardson Milam—himself a future president of Florida's Bar
Association—added statewide credibility and clout to the Davis organization.
Davis also opened regional sales offices from Tallahassee to Miami.[88]

Everything Davis did in the summer of 1924 led up to his ultimate goal:
the opening of land sales on Davis Islands. Davis spent lavishly on elaborate

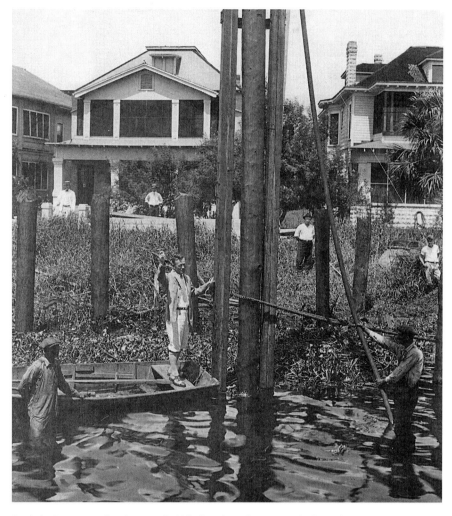

Davis is shown standing in a small skiff directing placement of pilings for the first wooden bridge built to the islands. Homes along the bayshore and curious bystanders can be seen behind Davis. *Courtesy of the Tampa Bay History Center Collection.*

brochures, a fleet of buses and vast improvements—costing an estimated $10,000—to the Franklin Street sales office. With the final design of the islands complete, maps were created showing lot locations. Davis divided the development into eight sections, six of which carried a name describing a particular feature or its proximity to nearby landmarks: the Hyde Park Section at the northern end of the islands nearest to Hyde Park; the Bay Circle Section just southwest of the Hyde Park Section, named for its

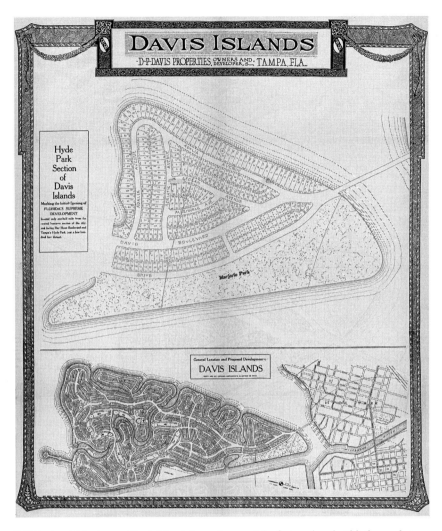

D.P. Davis sold the lots on Davis Islands by section, and the first section that hit the market was the Hyde Park section. This map shows both the Hyde Park section, which went on sale in October 1924, and the overall islands development as it was conceived. Hardly any sand had been dredged when this map was printed, so the outline, streets and most everything else were still in the planning stages. *Courtesy of the Tampa Bay History Center Collection.*

waterfront lots and circular street pattern; the South Park Section at the southern end of Marjorie Park; the Hotel Section, so named for the Davis Arms Hotel (which was never built); the Yacht Club Section, named for the Yacht Club, which, too, was not built; and the Country Club Section,

*Left*: Reproduction of the cover of *Life on Davis Islands, Tampa in the Bay*, a promotional booklet published in 1925 by D.P. Davis Properties. Artwork was by Harold K. Bement, Tampa, Florida, and printing was by Courier-Journal Lithographer, Louisville, Kentucky. *Courtesy of the Tampa Bay History Center Collection, gift of Frank R. North.*

*Below*: Davis made certain his prospective buyers would see his dream islands in style. Suits and straw hats seem to have been the proper garb to wear while touring the new development. A fleet of modern and luxurious D.P. Davis Properties buses are shown lined up in front of the administration building. This office building would become the Seaborn Academy in 1930, now known as Seaborn Day School. *Courtesy of the Tampa Bay History Center Collection.*

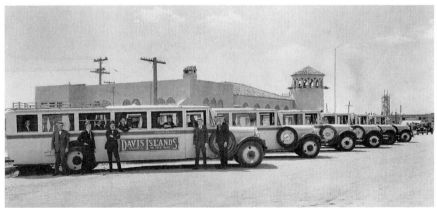

including five of the nine holes of the Davis Islands Golf Course and its clubhouse. The southern end of the islands, though platted, did not carry section names. Land sales, Davis decided, would go one section at a time. The fateful first day was finally at hand.[89]

The first sale of lots, the Hyde Park Section, came on October 4, 1924, fewer than four weeks after the favorable Florida Supreme Court ruling. The results of that first day's land sales are well documented—all available lots, a total of three hundred, sold within three hours at an average cost of $5,610 per lot. Few of those lots were above sea level, let alone graded and ready for construction. Some speculators waited in line for forty hours for the opportunity to buy into the yet-unbuilt islands. Total sales for that day reached an overwhelming $1,683,000. More interesting was the staggering resale of those same lots, some reportedly made inside the Franklin Street sales office between the first owners and eager prospects still waiting in line.[90]

Davis encouraged everyone to view his emerging paradise. Like many other real estate developers of the time, Davis owned a fleet of buses on which prospective buyers could tour Davis Islands. The buses, specially painted with the D.P. Davis Properties logo, brought people from as far away as Sarasota, Orlando and even Miami. Prospective buyers received colorful brochures, booklets and photographs showing how all their dreams could come true, just by buying property on Davis Islands. Venetian-style canals, luxurious homes, boating and waterfront grandeur were all depicted on lithographed pages within leather-bound booklets.[91]

Davis created a carnival-like atmosphere around his land sales, sponsoring boat races around the islands and along Bayshore Boulevard, airplane exhibitions with stunt flyers, sports celebrities' appearances—such as Olympic swimmer Helen Wainwright, who swam around Davis Islands—plus tennis tournaments and golf lessons from tour professionals Bobby Cruickshank and Johnny Farrell.[92]

The fervor created by the first land sale carried into the next, when lots in the Bay Circle Section went on the market on October 13, 1924. This scenario repeated itself each time lots came on the open market. As in Miami, Davis made sure to mention that many lots were purchased by "home folks" who knew a good investment when they saw it. Realizing the need to not flood that lucrative market, Davis spaced out the sales from days to weeks apart, allowing the property values to increase each time. Resales between individual buyers contributed to the frenzy of Florida's land boom, and the action surrounding Davis Islands proved

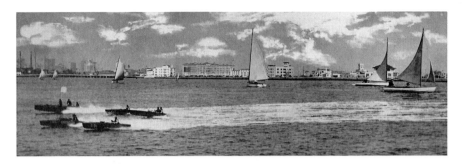

Advertising, both free and paid, was integral to Davis's promotional plan. He knew that he could garner much attention through extravagant events, such as speedboat races and airplane barnstorming. Davis established a racecourse for speedboats and even entered his own boat in the contests. *Courtesy of the Tampa Bay History Center Collection.*

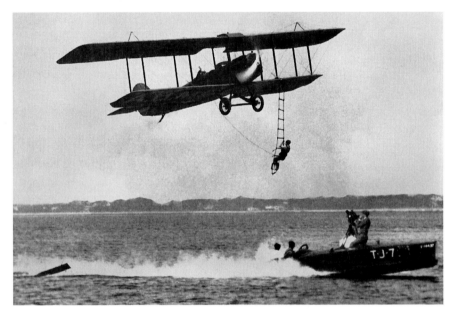

Davis spared no expense in marketing Davis Islands as the place to live and entertain in grand style. Here, a biplane stunt pilot was used as just one of several marketing promotions designed to bring attention to the development. *Courtesy of the Tampa Bay History Center Collection.*

*Opposite, top*: Davis's administration building is an example of the architecture that best typifies the Mediterranean-style influence of the hotels, apartments, offices and homes. The building houses Seaborn Day School today. *Courtesy of the Tampa Bay History Center Collection.*

*Opposite, bottom*: The interior of the D.P. Davis Properties administrative building was designed to impress prospective buyers with the kind of opulence that would be available to them if they bought into the islands dream. The room pictured here was where buyers would hear the main sales pitch. *Courtesy of the Tampa Bay History Center Collection.*

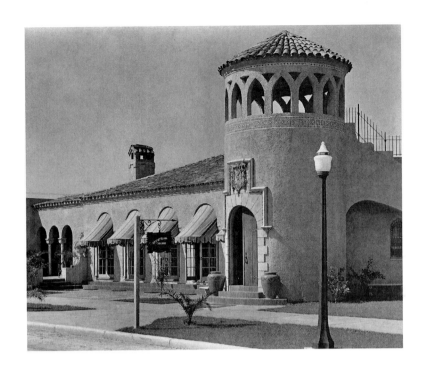

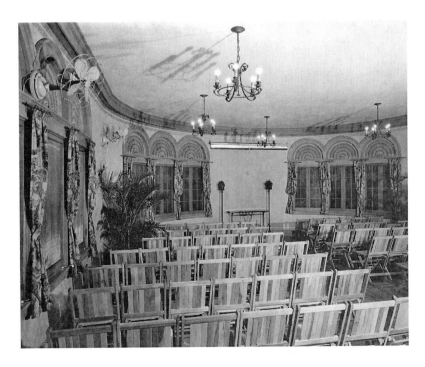

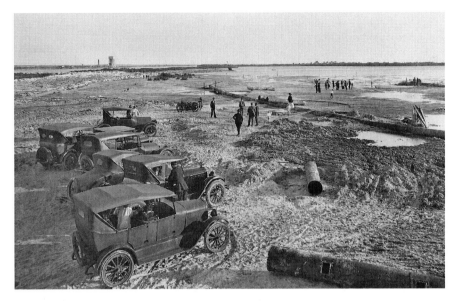

Another view of the dredging operation shows a crowd of smartly dressed visitors who arrived by car. Motorcycles can be seen at the center. Moms and dads in suits and hats appear to be scouting locations for their new dream homes. Two of the children seen running across the sand are George Davis II and D.P. Davis Jr. This view was taken looking southwest. *Courtesy of the Tampa Bay History Center Collection.*

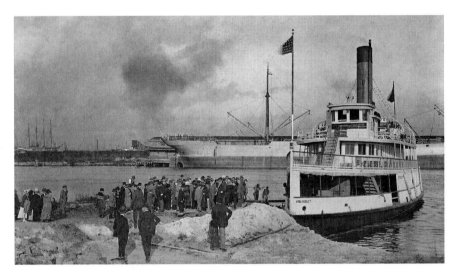

Davis knew that he needed to bring prospective buyers to his islands project as soon and as often as possible. He used every method at his disposal, including ferries and barges, to do just that. While on the islands, visitors could read the numerous billboards and signposts indicating the future locations of homes, hotels and business offices. *Courtesy of the Tampa Bay History Center Collection.*

no exception. Davis understood the importance of resales, both in how they maintained interest in his property and how they enhanced his own bottom line. He could raise the price on his own lots and, in theory, could also participate in the resale market himself. After October 15, 1925, when Davis offered the last section of lots for sale, resales were the only method of acquiring land on Davis Islands. [93]

Looking back at a very successful 1924 and ahead to all the opportunities in 1925, Davis likely spent New Year's Eve with friends and associates imbibing bootleg alcohol and laughing the night away. It is rumored that sometime during the revelry Davis made a boast that he would get married in the new year. What made the claim unusual is the fact that, as far as anyone knew, Davis was not involved with anyone at the time. It became almost unbelievable when he added that it would be to a woman whose identity was allegedly unknown to everyone—including Davis himself—declaring that he would marry the next queen of Gasparilla, the city's annual pirate-themed festival.

Throughout 1925, many of the real estate promises made by Davis and his company were becoming reality, such as homes, hotels, apartments, canals and parks. One key aspect of the islands' plan, a business district, also started to blossom. Billed by Davis as "congruous with the plan of establishing on Davis Islands an ideal residential city complete in itself," the business section centered on the Bay Isle Building, located at 238 East Davis Boulevard and designed by noted Tampa architect M. Leo Elliott. Elliott followed Davis's requirement that the building "harmonize architecturally with the surrounding Island beauty." Completed in 1925, the Bay Isle Building is still the anchor of the islands' business community.

Diagonally across East Davis Boulevard from the Bay Isle Building sat another commercial structure. Little is known about this second business building, except that it contained eleven storefronts; four facing Biscayne Avenue, five facing East Davis Boulevard and two opening south toward the neighboring property. A central arcade traversed the large building, which occupied four lots. The only evidence of this structure lies within the pages of the Sanborn Fire Insurance Company's maps of Davis Islands and within the rolls of Elliott's architectural renderings. In fact, it is quite possible that this structure never existed. The words "from plans" run beneath the schematic of the building on the Sanborn map. Aerial photographs from the time are of too poor a quality to determine if this mystery building actually stood on the southeast corner of East Davis and Biscayne.[94]

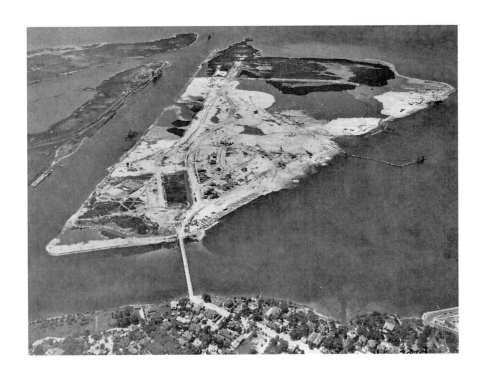

Houses, too, began to dot the sandy landscape of the growing islands. The architecture of these single-family structures strictly followed the design guidelines set forth by D.P. Davis Properties. Mediterranean Revival, Venetian, Italianate and Spanish styles featured soft pastel colors and intricate tile and figural designs. Two houses, one located at 32 Aegean and the other at 116 West Davis Boulevard, merit special attention. Both homes are associated with Davis. The West Davis Boulevard home has long been cited as Davis's personal residence. The existing historical evidence suggests differently, indicating that the home on Aegean was where Davis resided. Both homes are roughly the same size (around three thousand square feet), but the home on Aegean is directly across from Davis's office. In addition, the Davis family owns a photograph of 32 Aegean with the words "Davis home" on the back. The home on West Davis may initially have been Davis's home before 32 Aegean was completed, and if so, it likely transitioned into a "company home," since two presidents of Davis Islands Incorporated (successor to D.P. Davis Properties) occupied the home in the late 1920s and early 1930s.[95]

The concept of Davis Islands included both permanent and seasonal residents. As such, the islands' plan included several hotel and apartment projects. The most noticeable are the Mirasol, Palazzo Firenze (Palace of Florence), Palmarin Hotel (now known as Hudson Manor) and the Spanish Apartments. The Mirasol, Davis Islands's tallest building, sits at the end of a canal and has its own yacht basin. The Palace of Florence drew its inspiration from the Palazzo Vecchino in Florence, Italy. Designed by Athos Menebun and M. Leo Elliott for Philip Licata of the Tampa Investment Company, the Palace of Florence incorporated a variety of materials—such as terra cotta, wrought iron and stucco—and boasted a tower on each end of the front elevation.[96]

*Opposite, top*: This aerial photograph, taken in late 1925, demonstrates that building construction was underway while work on the islands' infrastructure—and the islands themselves—continued to the south. Completion of the seawalls and dredging was still two years in the future. *Courtesy of the Tampa Bay History Center Collection.*

*Opposite, bottom*: This home, located at 32 Aegean, was the home of D.P. Davis, his two sons and, occasionally, his second wife, Elizabeth, from late 1925 until his death in October 1926. The two-story home was close to three thousand square feet in size. It still stands today, but it has been added to and modified. *Courtesy of the Tampa Bay History Center Collection.*

Two large apartment buildings, the Venetian Apartments and the Spanish Apartments, immediately greeted visitors as they crossed the bridge onto the islands. The Spanish Apartments are unique in that the building was planned around a central courtyard—the only such multifamily building originally constructed on Davis Islands. *Courtesy of the Tampa Bay History Center Collection.*

*Above*: The Ritz Apartments, located on Davis Boulevard, was one of the smaller apartment buildings built on the islands. The overall plan for the project called for a variety of building types that would cater to a broad range of buyers. The Ritz was likely constructed for middle-class, winter residents who could afford to winter in Florida but could not, or would not, invest in property. *Courtesy of the Tampa Bay History Center Collection.*

*Opposite, bottom*: The Venetian Apartments—part of Davis's master plan for a complete community of lifestyles, incomes and interests—were built on the island side of the bridge, taking full advantage of the water and walking proximity to downtown. The sign in the photo reads, "Completely and luxuriously furnished. All appliances electric. Reasonable year round rates. Apply within." The building is no longer standing. *Courtesy of the Tampa Bay History Center Collection.*

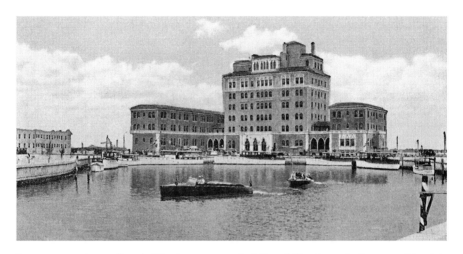

In contrast to the small-scale Ritz Apartments, the Mirasol Hotel was the largest residential structure completed on Davis Islands during this era. Originally built as a hotel, the postboom market forces dictated a shift to longer-term rentals. The Mirasol is still a popular apartment building today. *Courtesy of the Tampa Bay History Center Collection.*

*Opposite, top*: After the temporary bridge and main roads were complete on Davis Islands, buyers could drive onto the islands to visit the business office or to see their building lot. The number of cars lined up along Adalia in this photograph indicates that the picture was likely taken during one of the large section land sales. *Courtesy of the Tampa Bay History Center Collection.*

Some early residential buildings, notably the Biscayne Hotel, Bachelor Apartments and Venetian Apartments, have since been demolished. Others, such as the Augustine and Columbia Apartments on Columbia Drive and the Flora Dora Apartments and Boulevard Apartments on Davis Boulevard are still occupied. The Merry Makers Club, situated on land given to the club by Davis on the corner of Danube and Barbados, represents the only social club originally planned for the islands. The Davis Islands Coliseum, completed in 1925, embodied the largest single-building project originally planned for the community. Funded through the sale of stock certificates, the coliseum housed concerts, auto shows, conventions and even ice-skating, plus many other events within its auditorium, which was among the largest of its kind in the southeastern United States. Dances and formal gatherings, including Ye Mystic Krewe of Gasparilla's annual coronation ball, were also common during the coliseum's early years.

Among the original buildings currently hidden from view on the islands is the Davis Islands Garage. Located at the northern tip of the main island

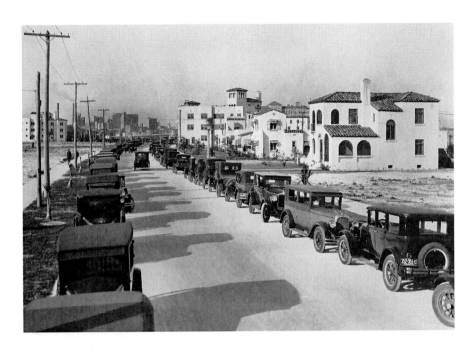

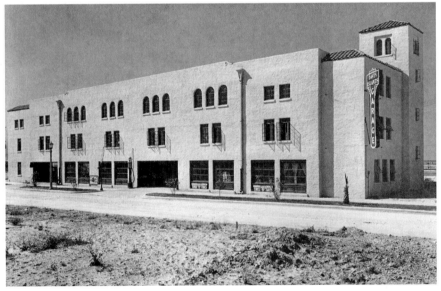

The Davis Islands Garage symbolized the notion that the islands development was built for automobile traffic. Unlike many of the contemporary neighborhoods established in Tampa during this time, mass transit—namely, streetcars—was never contemplated for Davis Islands. Wide streets, porte-cochéres and detached garages were important to the overall plan, as was the Davis Islands Garage. *Courtesy of the Tampa Bay History Center Collection.*

near the site of the original tennis courts, the garage reinforces the notion that Davis Islands was designed for people with automobiles. Though some of the residences had detached garages, some did not. Additionally, the apartment buildings and hotels had limited parking. The Davis Islands Garage accommodated the cars belonging to seasonal residents living at such a place. Part storage facility and part repair shop, the Davis Islands Garage fit architecturally, thematically and functionally into Davis's idea for a self-sufficient planned community.

Blessed in 1925 with success, cash and an extraordinary ego, Davis cast his determined stare in a more personal direction. One of the enduring stories regarding Davis at this time centers on what seemed his almost absurd New Year's Eve declaration that he would marry the next queen of Gasparilla. Davis once again, the legend goes, showed he could accomplish anything he truly desired, marrying twenty-two-year-old Elizabeth Nelson, Queen Gasparilla XVII, on October, 10, 1925—one month shy of his fortieth birthday. Gasparilla, Tampa's version of Mardi Gras, showcases members of Ye Mystic Krewe of Gasparilla, made up of Tampa's business elite, in pirate garb "invading" the city. In a more traditional sense, Gasparilla also was a social event complete with an annual grand ball and coronation of a king and queen. The king came out of the Krewe's membership and usually was in his forties or fifties, while the queen was the daughter of a Krewe member and was usually in her twenties.[97]

Assuming the story of the boast is true, how did Davis manage to fulfill his daring prediction? The naming of the court of Gasparilla is a secret, but it is decided in advance of the February coronation ball. Davis had a number of connections within Ye Mystic Krewe of Gasparilla (some sources list Davis as a member), and it is quite likely that he knew Nelson would be elected queen. During this era in Gasparilla's history, the queen was the previous year's first maid, and Nelson was first maid in 1924. The true mystery centers on their relationship during the time just before his New Year's Eve boast and their wedding day. It is unknown whether or not they had a secret relationship or if he had an unrequited desire for her, using his boast to gain her interest and attention. It is also possible, but much less likely, that he did not care who the next queen would be. We will probably never know.[98]

Davis and Nelson married eight months after the Gasparilla coronation ball, on the afternoon of October 10, 1925, at the "Presbyterian manse" in Clearwater (possibly Peace Memorial Presbyterian Church on Fort Harrison Avenue and Pierce Street). The only people to attend the hastily planned wedding were Nelson's sister Ruth Rorebeck and Raymond Schindler, one

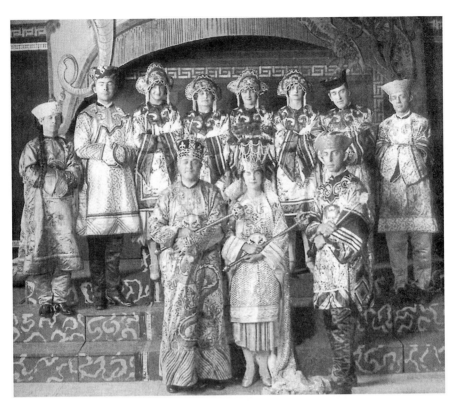

The seventeenth Gasparilla court, as pictured at their coronation ball in February 1925. This was the last coronation held at the Tampa Bay Hotel Casino. The following year, and for years after that, the coronation was held in the Davis Islands Coliseum. *Courtesy of Ye Mystic Krewe of Gasparilla.*

of Davis's business associates. The Nelson-Davis wedding was a surprise to many, not the least of whom included the Nelson and Davis families. Tampa's two daily newspapers, the *Morning Tribune* and *Daily Times*, each ran stories about the wedding in the following day's editions. Both papers related the basic facts, including Nelson's status as the reigning queen of Gasparilla. The *Tribune*'s headline, "D.P. Davis and Elizabeth Nelson, Prominent Tampans, Are Married in Clearwater; Surprise Families," topped that day's feature stories. The writer mentioned that "members of the immediate families were not informed that the wedding would take place during the afternoon until a short time before Mr. Davis and Miss Nelson left Tampa for Clearwater." The *Daily Times* article also addressed the secrecy behind the marriage, stating, "There were occasional rumors of the romance, but the marriage…

Elizabeth Nelson was only twenty-two years old when she married D.P. Davis. Their relationship was rocky, to say the least. Following Davis's death, she was courted by, and eventually married, Council Rudolph. Of Davis, Elizabeth would say little more than, "All I ever got from that marriage was a fur coat and some dishes." *Courtesy of the Davis Family.*

came as a complete surprise." The paper further alluded to her age, stating that she was "one of the most popular members of the younger set here."[99]

The honeymoon apparently was short-lived. Davis and Nelson divorced and remarried in the span of eight weeks. To say that Nelson's family, particularly her parents, did not like Davis would be an understatement. Rumor and innuendo flew as to the real reasons why the couple's relationship was particularly stormy. By this time, Davis had developed a substantial drinking problem, becoming a prominent symbol of Prohibition colliding with the Jazz Age. Like many men of his time, including Carl Fisher, Davis enjoyed the advantage Florida's coastline provided bootleggers who brought elicit alcohol into the state. While no evidence exists showing Davis's drinking affected his work, contemporaries acknowledge that it brought out his melancholy side and greatly affected his personal life. Many of Nelson's relatives—including her brother, grandson (from her second marriage) and great-nieces and nephews, plus Davis's son George—have related stories of Davis's poor treatment of Nelson. Perhaps the cruelest thing he did was trick her into divorce by slipping their divorce papers among a stack of other paperwork she needed to sign for D.P. Davis Properties. Though Nelson signed the document without realizing it, she followed through with the divorce proceedings, which occurred before Judge J.B. Browne of the Monroe County Circuit Court. Judge Browne granted the divorce on the grounds of "habitual intemperance." The decree was granted on November 4, just shy of three weeks after the marriage and

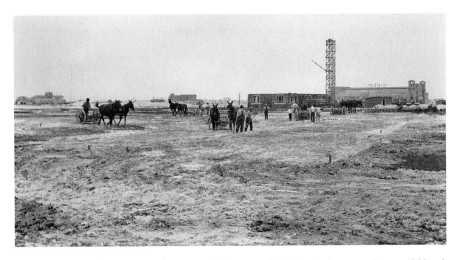

Once enough sand was pumped to a particular part of the islands, large graders would level out the land to allow construction to begin. Making sure everything was level was the job of surveyors and engineers, a whole team of which worked on the islands during the busiest days of 1925. *Courtesy of the Tampa Bay History Center Collection.*

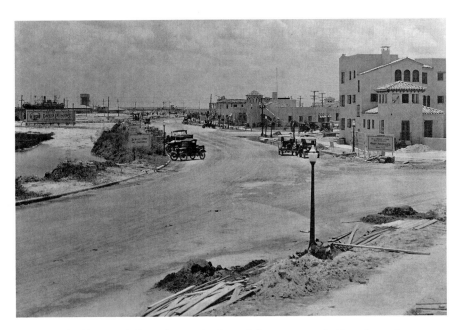

This view, looking south from close to the foot of the temporary bridge, shows the progress of infrastructure improvements and building construction on Davis Islands. The Spanish Apartments are shown on the right side of the frame. *Courtesy of the Tampa Bay History Center Collection.*

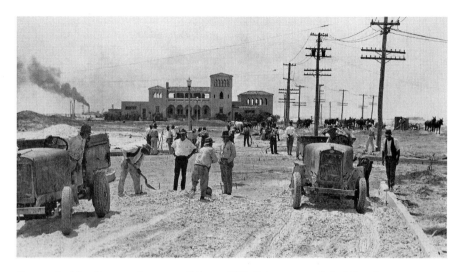

Even as the island's power lines, streetlights and Mediterranean-style buildings began to appear, work continued on the miles of curbing, roads and other infrastructure. Trucks joined the mule wagons in hauling dirt and fill. *Courtesy of the Tampa Bay History Center Collection.*

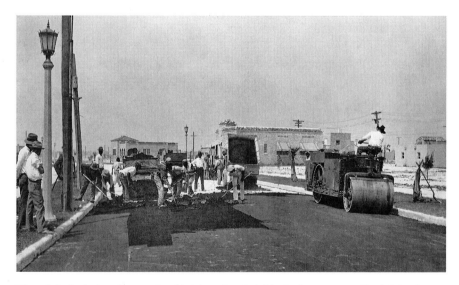

Though built during the era of red brick and asphalt block, the streets on Davis Islands were paved with smooth sheets of asphalt. This was fairly advanced for the time, but it produced a superior surface when finished. *Courtesy of the Tampa Bay History Center Collection.*

less than one week after they returned from their honeymoon. The Nelson family was likely happy with the divorce and was decidedly unhappy with the reconciliation. Davis and Nelson remarried on December 11. Newspapers said that "reports that friends and relatives of the bride had rejoiced over the reconciliation were denied by E.K. Nelson, Jr., brother of the bride"—hardly the welcome return that Davis had hoped for from his brother-in-law. Nevertheless, Davis and Nelson had reunited, but it was clear that their situation had not changed.[100]

Elizabeth Nelson was not the only woman in Davis's life. According to a newspaper interview with Milton Davis in 1971, D.P. Davis's marriage to Nelson was designed to make Lucille Zehring, whom Davis had continued to see since his Miami days, jealous. Davis and Zehring, who lived in Los Angeles during this time, maintained a long-distance, on-and-off relationship, which apparently was in an "off" stage during much of 1925. The relationship, however, was far from over.[101]

# CHAPTER 6
# DAVIS SHORES

## St. Augustine, Florida

D espite his success in Tampa, and partly because of it, Davis grew restless once again. As the Hillsborough Bay project was the next step for Davis to take from his Miami experiences, Davis Islands became a steppingstone to an even more ambitious project. That project, Davis Shores in St. Augustine, arguably led to his financial downfall and untimely death.

The same day that Davis completed sales on Davis Islands lots, and just five days after his marriage to Nelson, he announced plans for a new development in northeast Florida on St. Augustine's Anastasia Island. As in Tampa, St. Augustine's newspapers heralded the news of a new Davis development as a magical elixir. The *Evening Record*'s banner front-page headline on October 15, 1925, stated simply, "Davis to Develop Here."[102]

St. Augustine's history is as fabled as any place in the United States. Established in 1565 by Spanish conquistador Pedro Menéndez de Avilés, it is the nation's oldest city. Both fought over and neglected through the years, St. Augustine always maintained a presence on Florida's northeast coast, standing at the mouth of the Mantanzas River where it enters the Atlantic Ocean.[103]

More a point of entry than a destination, St. Augustine still attracted its share of characters. The city served as railroad tycoon Henry Flagler's Florida foothold in the 1880s but was roundly rejected in favor of its southern sisters during the early portion of Florida's land boom. Davis, born less than twenty-five miles west of the "Ancient City," planned to change that.[104]

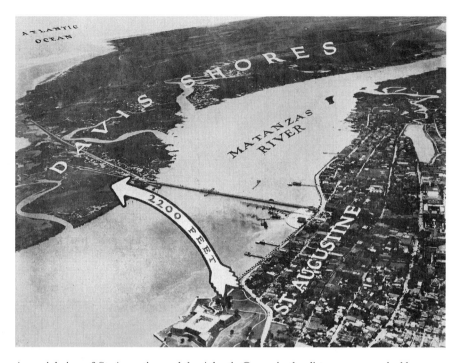

An aerial view of St. Augustine and the Atlantic Ocean in the distance was marked by Davis to show his new development, Davis Shores. Again, proximity to the town's main business district, "2200 FEET," was a big selling point. Davis would not live to see his dreams—here or in Tampa—fulfilled. *Courtesy of the Tampa Bay History Center Collection.*

If Davis's plans for Davis Islands seemed ambitious, those he held for Davis Shores appeared close to impossible. Davis asserted he would spend $60 million on the shores project, twice his pledge for Davis Islands. The layout featured a $1.5-million hotel, $250,000 country club, a yacht club and a Roman pool complete with a casino, each costing $200,000, as well as two eighteen-hole golf courses. The entire development would be crisscrossed by fifty miles of streets and one hundred miles of sidewalks. Each lot was designed to border a golf course or the water. Unfortunately for Davis, few of these plans would actually materialize.[105]

The lead architect for Davis Shores was Carlos Schoeppl, a partner in the national firm of Hedrick & Schoeppl. As with Davis Islands, the street names for Davis Shores held special meaning. The two main roads, Anastasia and Oglethorpe, have historic ties. Anastasia is, of course, the name of the island that formed the basis for Davis Shores. Oglethorpe is named for General James Oglethorpe, British founder of the Georgia colony in 1733.

He is thought to have set up an artillery emplacement on Anastasia Island during the 1740 British attack on St. Augustine. The Spanish governor who opposed Oglethorpe's forces, Manuel de Montiano, is likely the inspiration for Montrano Street. Spanish explorer Juan Ponce de León, who may or may not have traveled as far north as St. Augustine during his historic 1513 journey, was memorialized with two streets on Davis Shores, but they have since been renamed Alcazar Street and Flagler Street, both in honor of Henry Flagler. A figure often associated with Ponce de León, his pilot Antón de Alaminos, was also granted a street with his name. However, Alaminos Avenue never materialized because that area of Davis Shores was never dredged. Today's Inlet Drive follows a portion of the original avenue. Arredondo Avenue is named for Antonio de Arredondo, recipient of a large land grant. More specific to St. Augustine, he drew up a plan for defending the city in the 1730s. There is also a street named for an American Indian, Aripeka, who was an important Miccosukee leader during the Second Seminole War.[106]

Davis's decision to start a large-scale real estate project in St. Augustine was unusual. Previous developers, going back to Flagler, viewed the old city as merely a gateway into Florida. Davis was seemingly going in reverse, from Miami to Cocoa to Tampa to St. Augustine. Part of the reason lies with his partner, Arthur Y. Milam. Milam, along with J. Clifford R. Foster, adjutant general of the Florida National Guard, put the idea into Davis's mind. Jacksonville financiers, undoubtedly the Milam brothers and their associates, backed the project with a $250,000 investment. Davis placed Foster in charge of acquiring the land, a total of 1,500 acres covering the northeastern portion of Anastasia Island. This was accomplished in mid-1925, several months before the official announcement for Davis Shores. The St. Augustine evening newspaper did report that one of Davis's associates, George Young, was in the city to inspect the acreage owned by D.P. Davis Properties in June. Two months later, the paper reported that Davis's company paid the city $6,000 to widen the new bridge approach onto Anastasia Island to one hundred feet to accommodate the proposed development plans.[107]

The new bridge would come to be known as the Bridge of Lions. Plans for a new bridge from St. Augustine to Anastasia Island dated back to the 1910s, but it wasn't until the 1920s land boom that the city's civic groups were able to push the need to the forefront. Though not a part of Davis's plans for Davis Shores, the bridge fit well with the overall architectural look of both St. Augustine and the Davis development on the other side. The bridge officially opened on February 26, 1927.[108]

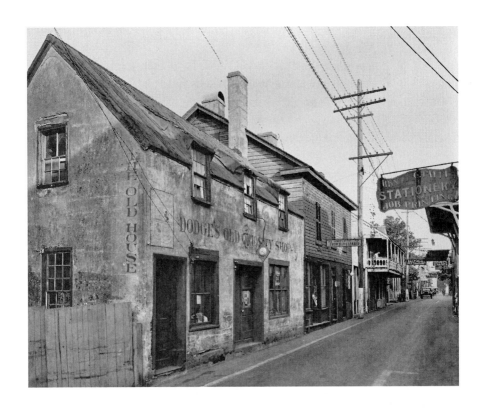

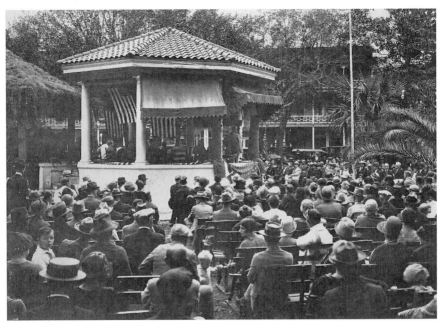

*Above*: Davis, in front with hat in his hand, is pictured in 1925 with Author Y. Milam and two unidentified men at the Castillo de San Marcos in St. Augustine. The Davis Shores development, with a cost purported to be $60 million, was located across the Mantanzas River from the Castillo. *Courtesy of the Tampa Bay History Center Collection.*

*Opposite, top*: St. Augustine is the oldest European city in the United States. Founded in 1565, it has lasted through invasions, epidemics, booms and busts. Davis's plans for the Ancient City were very ambitious but befitting of a city with such a long and diverse history. *Courtesy of the Tampa Bay History Center Collection.*

*Opposite, bottom*: Though Davis was unable to construct his sales office on the main square in St. Augustine, he did stage a large event there centered on the announcement of his plans for Davis Shores. The gazebo pictured here is still in use today. *Courtesy of the Tampa Bay History Center Collection.*

Anastasia Island already hosted a variety of homes and businesses, not to mention a lighthouse, before D.P. Davis announced his plans. Despite the natural land mass and vegetation, Davis decided to add to the northern end of the island to create Davis Shores. *Courtesy of the Tampa Bay History Center Collection.*

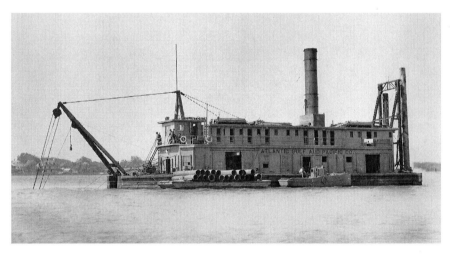

Davis insisted on adding to the size of Anastasia Island, so he enlisted dredge barges similar to the ones used for adding land onto Davis Islands. Unlike on Davis Islands, however, the dredges on Davis Shores did not finish their task, and a portion of the planned development remains underwater. *Courtesy of the Tampa Bay History Center.*

The early press regarding Davis Shores always mentioned the historic importance of St. Augustine, as well as its beauty and charm. Davis admitted that it would be a daunting task to integrate Davis Shores into the existing architecture of St. Augustine, which he consistently reminded people lay only 2,200 feet away. Advertisements for Davis Shores demonstrated his belief that the company was up to the challenge.[109]

Organization of Davis Shores's corporate structure would follow that of Davis Islands, with Davis and the Milam brothers in the top positions. Davis held the office of president, with Arthur Milam as vice-president and R.R. Milam general manager. A host of other positions filled out the corporate flowchart, including architects, accountants, engineers and stenographers. Davis utilized the old St. Augustine city hall building as his temporary sales office until he could construct his own building. He wanted to build the Davis Shores office on St. Augustine's main plaza, an area held sacred by many St. Augustinians. Citizens sued and won, forcing Davis to consider a spot south of the plaza on Aviles Street. That office would never be built.[110]

Despite the controversy over the location of the sales office, Davis was welcomed at a public reception at the same contested main plaza on November 12, 1925. Speakers for the occasion included St. Augustine mayor P.R. Perry and chamber of commerce president Judge David Dunham. The first stage of land sales began two days later, on November 14, 1925. Within a few hours, all available lots sold for a total value of $16,268,000. The first one hundred days of operation, Davis crowed, brought in a total of $50 million in lot sales. Unfortunately for Davis, that was the total value placed on the land. Buyers paid only a small percentage, usually 5 to 10 percent, as a down payment, with the rest coming in as monthly mortgage payments. Only a fraction (between $2.5 and $5 million—still no small number) of the $50 million actually flowed into Davis Properties coffers.[111]

As with Davis Islands, dredging—this time the northern portion of Anastasia Island—was a necessity for the ultimate success of Davis Shores. A "world record" dredging contract, which would go on nonstop until all thirteen million cubic feet of fill was in place, began on Halloween 1925, fifteen days prior to the first sale of land. Ultimately, it would be Davis who was haunted by the specter, rather than the spectacle, of Davis Shores.[112]

# "THE BUBBLE BURSTS"

In 1926, there were over 850 companies and individuals listed in the Tampa City Directory under its various real estate listings. The realtors covered Hillsborough County and west Central Florida, with a few touting investments in South Florida. Eighty-two of these companies placed real estate ads in the directory's special advertising section, up from 74 in 1925. Tampa banks, too, appeared very healthy—at least on the surface. During the first six years of the 1920s, total deposits in Tampa banks increased from just over $23 million to over $68 million, and the total number of banks increased from nine to fifteen. Other economic signposts of 1926 began to suggest a turn in another direction. The year began with news of slow real estate sales, a condition that did not worry Davis or most other Florida developers. But as the temperature increased from winter into spring, so did Davis's problems. Instead of receiving an expected $4 million in Davis Islands property payments, only $30,000 arrived. Both Davis Islands and Davis Shores had sold out by this time, and resales were moving slowly. In short, Davis had a serious cash flow problem.[113]

Con men had so infested the Florida real estate market—stealing millions of dollars from hapless investors across the United States—that potential buyers grew very skittish. Northern banks, too, grew weary of Florida investments. This stance against any Florida real estate investment soon spread across the country. The State of Ohio passed "blue sky" laws that forbade "certain firms" from selling Florida land in Ohio. This view was shared by a Chicago investment banker who claimed that "this Southern land boom is a fertile field for pirates of promotion." Though not a "pirate of promotion," Davis's luck changed as well, with more and more investors defaulting on their loans, starving him of much-needed cash.[114]

*Opposite, top*: The controversy surrounding the proposed location of a sales office in downtown St. Augustine had little to do with this building. This is a drawing of the proposed Davis Shores administration building, which would have been located on Anastasia Island. Like much of the project, this building never made it off of the drawing board. *Courtesy of the Tampa Bay History Center Collection.*

*Opposite, bottom*: On September 8, 1565, Pedro Menéndez de Avilés arrived on the northeast coast of Florida and founded the fort and town of St. Augustine, thus establishing Spanish dominion over the territory. Three hundred and sixty years later, D.P. Davis wanted to honor St. Augustine's founder with a memorial crypt for Menéndez on Davis Shores. *Courtesy of the Tampa Bay History Center Collection.*

The plan for Davis Shores called for the development to be roughly twice the size of Davis Islands. As such, the golf course planned for the community would also be twice the size, making it a regulation eighteen-hole course. The golf course never made it past the planning stages. *Courtesy of the Tampa Bay History Center Collection.*

Davis was not alone in his fall from realty grace. The entire Florida real estate market began a steady decline in 1926. As was the case with the start of the boom, Miami led the way in the decline. Problems began in 1925 when the Florida East Coast Railroad temporarily ceased freight service into Florida so the company could repair and update its line. In desperate need of building supplies, contractors and developers relied on improvised shipments aboard every kind of ship imaginable. That traffic came to a halt, too, after the ship *Prinz Valdemar* sank in the Biscayne Bay shipping channel in January 1926, rendering the channel all but useless. With faith in South Florida already faltering, the area was hit by a monumental hurricane on September 18. Winds in excess of 125 miles per hour tormented Miami for hours, accompanied by a devastating storm surge. Damage totaled into the millions, and the death toll reached over one hundred people. Florida's vulnerability had definitively been proven once again.[115]

Outside observers were also quick to point out that Florida real estate was not on a healthy footing. The *New York Times* reported a "lull" in the Florida market in February. By July, the *Nation* claimed that the real estate business in Florida had collapsed. "The world's greatest poker game, played with building lots instead of chips, is over. And the players are now...paying up."[116]

Davis Shores continued to draw away all available resources, resulting in slower construction on Davis Islands. An overall shortage of building materials, tied to both the freight embargo by the Florida East Coast Railroad and demand from around the state, made matters worse. Davis had little choice but to sell his Tampa investment.

## Davis Sells His Islands

The failure of a project on the scale of Davis Islands spelled potential catastrophe for Tampa, both in terms of pride and prosperity. A considerable number of important people had bought into the islands, and the outlook had turned bleak. Though the bulk of Davis's finances went through the First National Bank of Tampa, which had direct ties with Jacksonville and, potentially, with the Milam brothers, other investors, their money and their influences were undoubtedly also tied to Exchange National Bank, where Peter O. Knight served as a vice-president. Knight, who at the time was also president of Tampa Electric Company, had an intense interest in keeping Davis Islands afloat. Despite stories to the contrary, the dredging project was far from completion, roads awaited paving and large improvements such as the pool, the golf course and the promised bridge still lay years in the future.[117]

Knight convinced the Boston engineering firm of Stone & Webster, owners of Tampa Electric, to purchase Davis Islands. Stone & Webster formed a new subsidiary, Davis Islands Investment Company, which in turn purchased Davis Islands on August 2, 1926. Davis received 49 percent of the stock in the new company, which he immediately used as collateral on a $250,000 loan so work could continue work on Davis Shores. This amount proved far too small to plug the gaping holes in Davis's St. Augustine financing—Davis Shores was simply too expensive.[118]

Prospects did not look good for the state of Florida, nor were they looking good for Davis in his personal life. His wife, Elizabeth, along with her good friend Helen Freeman, departed New York aboard the White Star Line's RMS *Homeric*, arriving in Southhampton, England, on September 11. Their ultimate destination, according to the passenger list, was London's Hotel Metropole. Again, only speculation exists as to why Elizabeth left the country. Fewer than two weeks later, D.P. and his elder son, George, traveled to New York and then on to Philadelphia where, on the twenty-third, they

# MAJESTIC
## *The World's Largest Ship*

THERE are 106 other ships in the fleets of the White Star and associated lines and they offer 236 transatlantic passenger sailings for 1925, providing a complete ocean service to every European country directly or through convenient connections. Just the facilities that you want —whether a luxurious suite on the *Majestic* or a comfortable accommodation in the new Tourist Third Cabin.

## WHITE STAR LINE
### ATLANTIC TRANSPORT LINE · RED STAR LINE
### INTERNATIONAL MERCANTILE MARINE COMPANY
*No. 1 Broadway, New York; 127 South State Street, Chicago; 460 Market Street, San Francisco, Company's offices elsewhere or any authorized steamship agent.*

The RMS *Majestic*, hailed as the world's largest ship, was the luxury liner of choice for those who could afford the transatlantic journey. The ship made regular crossings, traveling between New York Harbor and Southhampton, England. *Courtesy of the Tampa Bay History Center Collection.*

attended the heavyweight boxing title match between the champion, Jack Dempsey, and his challenger, Gene Tunney. Father and son put a friendly wager on the match, with the senior Davis picking the underdog Tunney. His hunch was correct, and he was one dollar richer. That may have been the last dollar he earned.[119]

D.P. and his son George returned to New York one month later for a much bigger journey. They booked passage, with a disputed number of D.P.'s friends and associates, aboard the luxury liner RMS *Majestic*. The German-built ship was billed as "the Largest Steamer in the World" and was owned and operated by the Cunard Line of steamships. The ship made regular trips between New York, Great Britain and France, catering to the wealthy and world-wise.

# CHAPTER 7

# HIGHS AND LOWS

## Casualties of the Boom

Davis would not live to see the end of the transatlantic voyage, much less either of his monumental projects, Davis Islands or Davis Shores, completed. Stories of his death always include some element of mystery. The only undisputed facts are that he went overboard and drowned while en route to Europe aboard the ocean liner RMS *Majestic* early in the morning on October 13, 1926, and that both Lucille Zehring and his ten-year-old son, George, along with Schindler, his attorney, LeRoy Delaney and Davis Islands public relations man Forrest Montayne, accompanied him on the voyage. What is in question is how he ended up in the water. Speculative answers include accidentally falling out of a stateroom window, being pushed out or jumping out to end his own life. A multitude of stories fill the void.[120]

Victory National Life Insurance Company, founded by Sumter Lowry, (a member of Tampa's City Commission in 1924) sold Davis a $300,000 policy a few months before his death. Davis held policies with other insurance companies and, since his body was not recovered, some felt that Davis faked his own death. Lowry, "anxious to make a reputation for paying claims promptly," hired an investigator, who, in Lowry's words,

> *went to England and talked to the Cunard Line offices. They established the fact that a reliable steward had been standing outside Mr. Davis' cabin and he heard voices in the cabin. In a few minutes one of the parties in the cabin rushed out and said that Mr. Davis had gone overboard.*

The steward had seen Mr. Davis go in the cabin, and he had never left his position at the door until the announcement was made that Mr. Davis was lost. He rushed in the cabin, which was small and impossible for a man to hide himself in. The cabin was empty. D.P. Davis was gone.[121]

Lowry paid out the claim based on the investigator's conclusion that Davis was indeed dead.

Lowry's findings regarding Davis's death did not assuage all doubts on the subject. Many felt that Davis leapt overboard to end his life. Chief among this theory's proponents was the captain of the *Majestic*. Another who thought Davis killed himself was Jerome McLeod, who had joined D.P. Davis Properties in 1925 as assistant publicity director after a stint at the *Tampa Daily Times*. "He got drunk," McLeod told a later interviewer, and "when he got drunk he got maudlin." A third story comes from a steward who stood outside Davis's room and overheard an argument between Davis and Zehring. The *Majestic's* employee claimed Davis said, "I can go on living or end it. I can make money or spend it. It all depends on you." The statement was punctuated by a loud splash. This runs somewhat counter to the testimony given to Lowry, in which the steward had to be told of Davis's fall by Zehring.[122]

Davis's brother Milton had a different story. While acknowledging D.P. Davis had a drinking problem, he believed his death was an accident. Milton traveled to New York City to speak with Zehring about his brother's final moments. Milton, who claimed David probably intended to divorce his second wife and marry his girlfriend, restated Zehring's recollection: "Lucille said there had been a party and D.P. was sitting in an open porthole, one of those big ones. It was storming outside, and he blew out the window. She said she started to scream and grab his leg, but it was blown out of her hands. That's what happened."[123]

Davis's representatives, attorney Delaney and PR man Montayne, had slightly different versions when compared to other accounts and even to their own. Delaney released a statement saying that Davis pretended to jump out of a window in his stateroom, only to slip and actually fall overboard. He claimed that Davis was entertaining two widows, Alice Smith and Lucille Zehring, whom he met during the transatlantic voyage. The widows stayed in Southhampton, the ship's destination, but Davis's party continued on the train to Paris. Elizabeth Davis had sent a message to D.P. the day before saying that she would meet the train in Paris, but she was not at the station. According to the attorney, she had been traveling abroad for several months and was staying at a different hotel than the rest of the party. He finally

claimed that Davis likely left $30 million, which would be divided evenly between his sons and his widow.[124]

Montayne's story was slightly different but not much more accurate. He claimed that Davis and Zehring had met the previous fall while she was a guest at an apartment house on Davis Islands. Montayne also asserted that Zehring was a "member of his party" and that she and Davis had been inseparable since dinner and were alone in the sitting room of his suite when he went overboard. Montayne also quoted the report submitted by White Star line officials, which stated:

> *Mrs. Zehring, while unable to give a very clear account of the matter, evidentially owing to the shock, recalls Mr. Davis saying for her to catch him as he was slipping, but although she caught his arm for a second, he was gone before she realized it and her screams brought the night watchman who as stated alerted the bridge at once and the search for him was started immediately.*[125]

While there were obvious differences between Delaney's and Montayne's versions, there are a couple points they agreed on. One was the time of Davis's death, which could not be lied about. He went overboard in the early morning hours of October 13—around 5:00 a.m.—with both agreeing that it was not unusual for him to be awake at that hour. Another, more important detail, on which they agreed was that they both denied the rumors that Davis had committed suicide. They even used the same phrase, stating that he was in "good spirits" that evening.[126]

One voice that had been silent for almost eighty years belonged to another person who was onboard the *Majestic*: Davis's son George. Interviewed in 2005, George certainly knew of the controversy. "As far as the question I know that everybody has, I'm sure that you could make a pretty solid case, yes it was suicide, or a pretty solid case no it wasn't suicide. Take your choice." He did not leave it at that, though. He went on, using his phrase, to make his choice, saying that he believed that his father committed suicide. He remembered very little from that evening. "I was very sad, crying. I started hearing people talking about the cause, or their opinions of causes. I can't say specific commotion. I probably slept through the sailing around and around looking for the body, but I don't remember it. The after-effects were bad."[127]

Aside from George Davis's personal memories, there are a variety of problems and inconsistencies with each of these stories. Some say that Davis

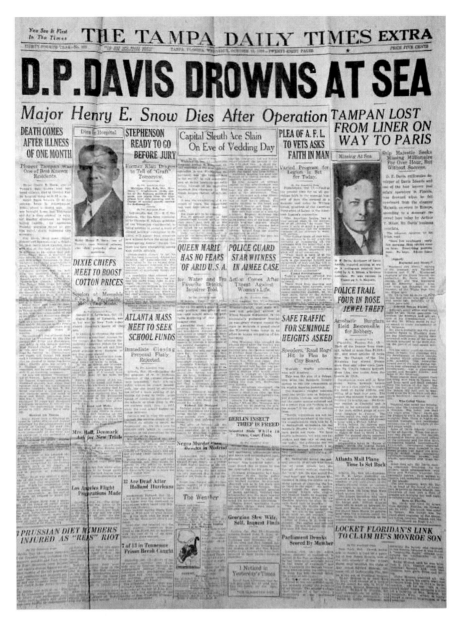

Most Tampans were informed of the news of Davis's death on the afternoon of October 13, when this extra edition of the *Tampa Daily Times* hit the streets. Newsboys must have hawked the paper, yelling out the banner headline, much as Davis was alleged to have done on the same streets when he was a boy. *Courtesy of the Tampa Bay History Center Collection.*

and Zehring were alone while others say there was a party. It is unlikely that the steward standing outside the closed stateroom door heard a loud splash that occurred outside the shop and dozens of yards below the open window. The idea that Davis booked passage with a large party, including Davis Properties employees, places doubts that the intent of the voyage was to divorce his wife, but given Davis's bravado and impulsiveness, this cannot be completely ruled out.[128]

Davis's drinking problem unquestionably contributed to his untimely death, but to what degree is difficult to say. Some point to the possible fight with Zehring and others to his overall financial collapse as reasons why he would commit suicide. Alcohol inevitably compounded those problems. Others, like Davis's brother, felt that his alcoholism merely put him in the position of hurting himself, intentionally or otherwise. Yet another theory intimates that Davis faked his death. This was initially discredited by Lowry's investigation and subsequently by Milton's assurances to the contrary. His sons also ruled out this possibility. Murder, too, is a possibility. Some stories relate that Davis had up to $50,000 in cash with him. Others discount this, claiming that he hardly ever carried large amounts of money. Motive and opportunity do not seem to be on the side of murder, but no one could lead his life without making enemies, especially after losing so much money in such a brief period of time.[129]

Wrought with grief and accompanied by his father's mistress and business associates, George's sad and terrible trip to France took a brief turn toward the absurd. For reasons unknown to him, Zehring took George on a short tour of Paris. "I'm sure it was my dad's girlfriend that took me around Paris," Davis recalled in 2005. "I remember going up the Eiffel Tower. I remember going into Napoleon's tomb, very definitely remember those. We went to the Moulin Rouge, which is the topless type place. I was impressed with that." When asked why she would take a ten-year-old-boy to the Moulin Rouge, not to mention one whose father was just lost at sea, he replied simply "I guess she wanted to see it. I don't know."[130]

At some point Elizabeth Davis took custody of George, and she accompanied him back to Tampa, arriving in the United States on October 29 and Tampa on November 1. Both Montayane and Delaney were also on the return voyage across the Atlantic, but Delaney remained in New York while Montayne made the final leg of the journey by train with George and his stepmother. Zehring and Schindler did not return to the United States until November 1. Of all the known witnesses and associates on board the *Majestic*, Schindler remains the only one whose thoughts regarding Davis's

death are not known. The only communications attributable to him were the radiograms coauthored by him and Montayne, the second stating that Davis's death was "purely accidental."[131]

Almost as interesting as the mystery surrounding Davis's death was the tabloid treatment given the story in the following weeks and months. Davis's involvement with Zehring provided much of the fodder for the stories, but his own fame, fortune and ultimate misfortune contributed mightily to the story. The *American Weekly*, a Sunday news insert comparable to a news tabloid today, printed at least two stories on Davis's death and his connection to Zehring in 1927. The first issue recounted Davis's life, from his beginnings as a newspaper boy in Tampa to his time in Miami and finally his rapid rise and fall in Tampa. The writer points out that at each bump in Davis's road, he could have ended his life and nobody would have been surprised, but at the time of his death it seemed that he also had the most to live for. Some interesting details regarding the fateful night on the *Majestic* include an interview with Zehring, in which she says that they both had attended a champagne party in someone's stateroom and then returned to Davis's room for a few more drinks. They later argued for over an hour before he pretended to jump out of his window. When he slipped, she grabbed his ankle (her original story said it was his arm), but she could not prevent his fall. The story ends with an interesting twist—that he had been traveling with a large sum of money ($35,000) that was missing.[132]

The follow-up article was even more sensational and featured more information from Zehring. She allowed the paper to reprint two letters allegedly written by Davis to Zehring in July and August 1926. The letters portray Davis as both personally lovesick and professionally frustrated. They were written while Davis was negotiating the purchase of Davis Islands by Stone & Webster. Davis intimated that when the sale was finalized he would divorce Elizabeth and marry Zehring. The timetable he estimated matches fairly well with the timing of his trip on the *Majestic*. The article ends with a quote by Zehring: "Things were just breaking right for him. Why would he commit suicide? He didn't, of course, and he wasn't drunk either. He drank very little." While the first part of that statement will never be fully confirmed or refuted, the latter part has been contradicted by many, including Zehring in her previous appearance in *American Weekly*.[133]

## Davis Islands Awarded

Though he never saw his creation to completion, Davis's dream of a model community became reality. Validation for his determined plan for Davis Islands came in 1927, when the American Association of City Planners awarded its first prize to the development. The association pointed favorably to the layout, which, "embraced sixty streets, representing a total of twenty-seven miles of broad, curving boulevards sixty to 100 feet in width, and several miles of picturesque, winding waterways." In fact, Davis's original plan provided for nearly eleven miles of waterfront locations and a large amount of golf course frontage for fine homes. It was so planned that not any residential lot in the entire property would be more than 500 yards from the water.[134]

The award was as much for Davis's visionary planning as for Stone & Webster's continued execution, referred to in the last sentence of the commendation: "The development of these features has continued throughout the property with provision of all utilities enjoyed by the most exclusive residential communities."[135]

Davis Shores did not fare as well as Davis Islands. None of the grand buildings was ever constructed, and only a handful of the small apartment

This membership card to the Davis Islands tennis club belonged to Luella "Billie" Webb, who was a secretary for D.P. Davis Properties. Interestingly, she also lived next door to Davis's father and stepmother on South Boulevard. *Courtesy of the Tampa Bay History Center Collection, gift of Frank R. North.*

buildings, not to mention the hundreds of homes planned, were completed. Davis Shores went into receivership and much of Davis's original plans, including the basic layout of the development, changed. Jack Thompson and Harold Ryman replatted part of the development after World War II, when Florida entered another land boom and many 1920s-era developments, including Davis Shores, gained new life.[136]

## STONE & WEBSTER CONTINUES DAVIS'S VISION

Stone & Webster continued construction on Davis Islands in late 1926, with attention focused primarily on infrastructure. The company placed an advertisement in the *Tampa Morning Tribune* trumpeting, "Dredging Hits Record Speed." The piece continues, telling of the launching of a "new million dollar contract" just signed with Northern Dredge & Dock Co., the same company Davis originally hired for the project. The new owners of the islands were eager to get the project back on its feet. "In an endeavor to expedite and complete the dredging at an early date, a

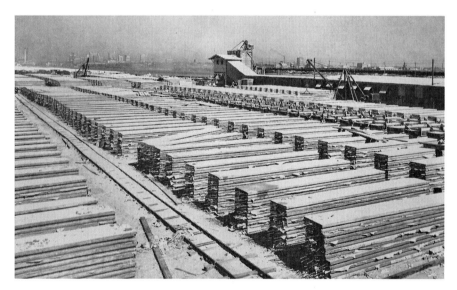

Much like the plants for landscaping, all the building materials for the islands had to be delivered to the job site. Workers needed enough boards, blocks, concrete, nails and other materials to keep busy, so a supply yard was established on the southeastern portion of the islands. *Courtesy of the Tampa Bay History Center Collection.*

provision of the new dredging contract allows a bonus to the dredge company any month that more than 600,000 cubic yards of fill are placed." Northern Dredge operated six dredges at the site and planned on adding a seventh as soon as possible. The newspaper ad ended with the announcement that "600 workmen have been added, 2,157 feet of sanitary sewers installed, 2,900 feet of water mains laid, 3,000 feet of gas mains placed and 250 lots graded."[137]

Stone & Webster moved their Tampa offices from 101 Tampa Street in downtown to Davis Islands, possibly as a show of support for the islands' business district. Their first islands' office, in 1927, was located on the corner of Columbia and Barbados. The company moved to the second floor of the Bay Isle Building in 1928. By 1930, however, they abandoned the islands altogether—a harbinger of things to come.[138]

## CHANGES IN THE DREAM

With the transfer of ownership from Davis's D.P. Davis Properties to Stone & Webster's Davis Islands Incorporated came increased flexibility in the design restrictions. The Kornell Apartments, completed in 1928 and located at 25 Davis Boulevard, were a radical departure from the Mediterranean style required by Davis. Several residences also deviated from the prescribed style, examples of which still exist at 26 and 116 Adalia. Davis Islands Incorporated continued construction on the islands for the benefit of both private and business residents. The firm also pursued the internal improvements included in Davis's original plans, which were necessary for the smooth flow of the increasing automobile traffic. The permanent bridge leading to Davis Islands was dedicated in a ceremony featuring Tampa mayor Donald B. McKay and Howard G. Philbrook, president of Davis Islands Incorporated, on May 16, 1928. It took nearly eighteen months to complete the bridge, with a portion of the time spent fighting an injunction by Patrick and Euphemia Kelliher, who claimed the bridge infringed on the riparian rights of their property at 105 Bay Street. The Florida Supreme Court dissolved the injunction, allowing construction to continue.[139]

Of all the amenities originally designed and constructed for Davis Islands in the 1920s, the Davis Islands Golf Course was the largest in scale and the latest to be completed. Designed by "internationally known" golf

course architect A.W. Tillinghast, the golf course occupied a large portion of the southern half of the islands, where it was entwined within the streets and canals of the development. Construction began on the course in late January 1927, four months after the engineering firm of Stone & Webster purchased Davis Islands from D.P. Davis, and three months after Davis's mysterious death at sea. The start of construction was heralded by the development's newspaper, *Life on Davis Islands*, with the banner headline, "Golf Course is Begun." [140]

The straightforward course layout consisted of nine holes, covering 3,060 yards. The only water hazard of any significance was the 100-foot-wide Grand Canal that cut across the middle of the second hole. The same canal sat behind the green on Number One and ran behind the tee box on Number Seven. Sand bunkers seemed the bigger obstacle, with as many as five appearing on a given hole.

The clubhouse, located between the fairways of Number One and Number Nine, was finished and opened three years before the course opened. The Mediterranean Revival–structure stood two stories tall and featured dining rooms, meeting space and a dance floor. More interesting, however, was the retractable roof that could be opened to allow dancing under the stars. The building operated as a supper club before being converted back to its original purpose, that of a proper country club.

Opening festivities took place on December 31, 1928, with revelers simultaneously ushering in the New Year and the new golf course. A members-only tournament was held the following day to officially open the course. According to the January 15, 1929 edition of *Life on Davis Islands*, membership to the country club was restricted and set by a meeting of "prominent Tampans" in December 1928. Memberships for winter visitors, still a big target demographic even after the bust, were also available. [141]

Another, more important, story also appeared in the January 15, 1929 edition of *Life on Davis Islands*. The lead engineer of Davis Islands Incorporated announced that the "fundamental improvements of Davis Islands today are 100% complete with but a small portion of the incidental development work together with the extension of planting and beautification in some of the southern parts of the property yet to be done." One of those "incidental" pieces was the completion of the "Roman Pool," which was to be a focal point of recreational activity on the islands. The pool was similar to the one located north of Tampa at Temple Terrace, another 1920s community. Other area pools were at Palma Ceia Springs by the Bayshore (present-day Fred Ball Park) and the pool at Sulphur Springs. With the exception of the

Davis Islands was one of many 1920s, Tampa-area real estate developments. Forest Hills, located north of Tampa, featured many of the same amenities as Davis Islands, including a golf course. Burks Hamner, who may have originally come up with the concept for Davis Islands, was the lead developer behind Forest Hills. *Courtesy of the Tampa Bay History Center Collection.*

Rivaling Davis Islands in scope and importance was the development originally known as Temple Terraces, which became known as the City of Temple Terrace. The Mediterranean Revival–themed city included an eighteen-hole golf course, a large swimming pool and hundreds of home lots adjacent to extensive temple orange groves. *Courtesy of the Tampa Bay History Center Collection.*

Temple Terrace pool, which has since been removed, no other pool in the city was as ornate as the pool on Davis Islands.

Located on the corner of Columbia Drive and Bosphorous Avenue and built at a cost of $75,000, the original plan for the pool was as elaborate as the rest of Davis's plans for the islands. Unfortunately, the financial climate had cooled when the time finally arrived to build, so the Davis Islands company had to adjust the building plans accordingly. Looking back, it is amazing that the facility was constructed at all; cost-saving measures would have been the rule, and corners were cut in a variety of places, from the overall scale of the pool and ancillary buildings to the interiors of those buildings. According to a September 15, 1929 *Tampa Morning Tribune* article, the company "changed the plan to use high grade wooden lockers to ready-built metal lockers from Ohio" because of the need for "home labor" to be used on other projects. Though construction projects did continue in 1929, there were far fewer and at a much slower pace than during the boom era of the mid-1920s; more workers were not needed. A more likely reason is that budgetary constraints allowed for neither the high-grade lockers nor the skilled labor necessary to build and install them.[142]

The pool did feature a number of modern conveniences and what were considered high-tech mechanisms designed to keep the pool and its patrons clean. The pool water was treated with alum and lime and then sterilized with chlorine. Among the technological advances were "rapid sand filters," showers and a circulating water basin, intended to both wash contaminants off swimmers before they reached the pool deck and to discourage people with street shoes from walking on the deck at all. The 1929 *Tribune* article boasted, "Tampans and their visitors will swim in water pure enough to drink."[143]

The Davis Islands pool was part of a bigger plan for the southern end of Marjorie Park on the eastern side of the islands. The overall layout was to include dressing rooms for four hundred bathers, two hundred for the pool and two hundred more for a "sunken pool" to be built to the south; a children's pool; a playground; and solariums "placed in an adjoining garden." According to Davis Islands Incorporated president George Osborn, the entire block was to be a "pleasure ground for kiddies and grownups." Most of those features were not constructed, though there was a garden just to the south of the main entrance to the pool, which is now the site of a small playground. The Davis Islands Pool represented one of the last large-scale projects funded by Davis Islands Incorporated.[144]

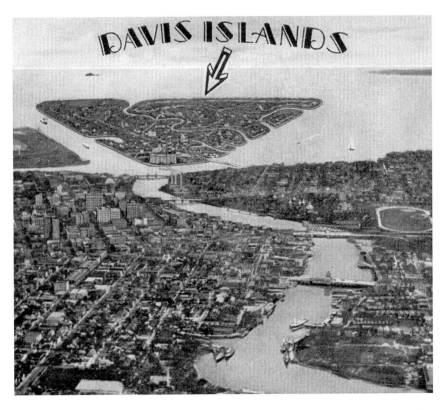

This aerial view of Tampa and Davis Islands is reproduced from a page in *Florida's Wonder Spot*, a promotional pamphlet published in 1928 by Davis Islands Incorporated. The booklet features photography by the Burgert Brothers and Carl T. Thoner, artwork by Arnold Meyer, engravings by Tampa Photo Engraving Company and was printed by Florida Grower Press. *Courtesy of the Tampa Bay History Center Collection.*

Davis Islands Incorporated continued to advertise the virtues of visiting and living on the islands, but a reduced marketing budget directed the message to a different target audience. The prospective buyer was not the same one who originally rushed to buy lots on the first day of land sales in 1924. A 1928 Davis Islands brochure titled *Florida's Wonder Spot* still touted the location, convenience, fun and luxury of the property, but the printed piece was produced on a smaller budget. Paper quality, artwork and design were all affected by the low-cost approach. The greatly expanded use of photography rather than the fanciful artwork of previous sales brochures was another difference but was probably due as much to the fact that there were more finished buildings to photograph in 1928 as to the reality that the creating and printing original drawings was more expensive.

Flowery language was another casualty of the new times. One of the captions for a photograph of the Mirasol Hotel gives an example of these changes: "The Mirasol—one of the Davis Islands Hotels—where the visitor finds real resort luxury at moderate cost." As a comparison, the hotels in *Life on Davis Islands, Tampa in the Bay*, produced by D.P. Davis Properties in 1925, were "robed in quiet refinement where everyone…free from care, may enjoy the vitalizing Island life that beckons near at hand." When placed next to each other, the post-Davis version is somewhat lacking. Some silvery prose is still present, but it is definitely tarnished. The year 1930 saw the end of the old Davis marketing machine, when the administration offices moved from 32 Davis Boulevard into space on the second floor of the Bay Isle Building—the offices recently vacated by Stone & Webster. The Davis Boulevard office became the Seaborn Day School that same year.[145]

One of the most enduring and dominating features of Davis Islands—Tampa General Hospital (originally known as Tampa Municipal Hospital)—never appeared in the original plans for Davis Islands, nor did it originally appear, it is safe to say, in the wildest imagination of Davis Islands's creator.

The effort to open a public hospital in Tampa took many years before coming to fruition. Before 1910, Tampa's white citizens who were sick or injured had to go to the Emergency Hospital, located at 908 Lafayette Street (now Kennedy Boulevard), the Tampa Bay Infirmary at the Tampa Bay Hotel (now the University of Tampa) or, for women, the Women's Home and Hospital at 105 West Ross Avenue. All three institutions were small and offered only limited care. The Emergency Hospital and Women's Hospital were both housed in two-story, wood-frame buildings that originally were private homes, while the Tampa Bay Infirmary, though built as a medical clinic, was too small for Tampa's growing population. Tampa's black community could not take advantage of these institutions, relying on the few local black doctors or, occasionally, a white doctor willing to cross the rigorous color line of the times. It wasn't until an African American nurse named Clara Frye, with the help of a white doctor, opened her home in the early 1910s to everyone in need, regardless of race, that Tampa's black community had access to quality medical care.

On June 1, 1910, the thirty-two-bed Gordon Keller Memorial Hospital opened at 306 North Boulevard, adjacent to the Tampa Bay Infirmary on the grounds of the Tampa Bay Hotel. The facility was named in honor of a noted Tampa businessman and city treasurer Gordon Keller, who died in 1909. Funds for the hospital were raised in part by Keller's friends and admirers who were eager to memorialize Keller's contributions to the community.

Unprecedented population growth in the early 1920s taxed the small Hyde Park hospital. While the city initially wanted to expand the existing facility, the idea proved impractical, and the search for a new hospital site began. A site committee suggested building on Davis Islands, using a portion of parkland deeded to the city by Davis and his company.

There is, of course, a story related to the hospital's location on Davis Islands. The story goes that, while playing golf at Palma Ceia Country Club with Dr. J. Brown Farrior and James Swann in early 1925, Davis asked Farrior where he wanted the new hospital. Davis drew a rough outline of the islands in a sand trap, and Farrior pointed to the northern tip as the preferred location. Whether the story is true or not is unimportant. What is true is that Farrior headed the construction committee and Swann served as chairman of the new hospital's board of directors.

One hurdle still existed: the proposed location in Marjorie Park still sat under water. Davis promised to have the land available as soon as possible, and in March 1926, construction began on the modern 250-bed facility. The Gordon Keller Nursing School, which was a part of Keller Memorial Hospital, moved to the islands and opened with the new hospital in 1927. Continuing the celebration of Keller's life, an inscription on the archway over the new hospital's entrance read, "Tampa Municipal Hospital Memorial to Gordon Keller."

Real estate promotion in Tampa, and across Florida, continued its free-fall in the latter part of the 1920s. In 1927, only 29 realty companies purchased space in the advertising section of Tampa's city directory, down from 82 the year before. The total number of realtors that year plunged by half to 416. Only 292 appeared in the 1928 city directory, with 21 of those taking out special ads. By 1930, only five real estate companies placed ads in the directory, a 94 percent decrease from 1926. Tampa banks felt the vast reduction in real estate sales and construction work. Bank deposits dropped sharply between 1925 and 1926, from over $100 million to nearly $69 million. They dropped by over 10 percent the following year, and by 1929, deposits dipped to $32 million. The final blow, of course, was the stock market crash on October 29, 1929. The rest of the country was simply joining Florida in economic depression. All hope of a recovery in Florida real estate was now lost. Davis possibly felt the inevitable approaching and did not want to be around to see it. His islands would again become desirable property, but it would take another world war and another Florida real estate boom, caused by the strong economy and incredible population growth in the 1950s, for it to happen.[146]

## DAVIS'S LEGACY

David Paul Davis was among the most notable casualties of Florida's real estate boom and bust. Countless subdivisions were left in its wake, often just paved streets leading to nowhere. Eventually all of Davis's properties would prove successful. In Miami, his Commercial Biltmore development has seen new life in the form of the city's fashionable Design District. The same holds true for Davis Shores, though it did not reach completion until the 1950s.

Davis's family experienced the usual mix of success and failure typical to most Americans. His brothers worked with him on Davis Islands, with Milton carrying the Davis name to Fort Myers and Havana, Cuba. The brothers eventually returned to Davis Islands in retirement, living out their golden years on their big brother's island.[147]

Their sister, Elizabeth Hodgson, remained in Tampa with her husband until 1949. George Hodgson, David's brother-in-law, worked in a variety of capacities for Davis Properties, Davis Islands Incorporated and the Davis Islands Garage. Eventually, the Hodgsons left Tampa, retiring in Bradenton Beach, Florida.[148]

George Riley Davis passed away on February 13, 1930, at the age of seventy-three, after a brief illness. He died at Tampa Municipal Hospital, located at the northern tip of Davis Islands. His youngest brother, Howell, served two terms as mayor of Palatka and continued their father's business until his death in 1957. David P. Davis's sons, George Riley II and David Paul Jr., were both sent to live with their mother's aunts in California following their father's death. They both lived long and productive lives, with each living into their eighties.[149]

Davis Islands continued to move forward as well. The 1930s would start slowly, but by the end of the decade, things began to heat up on the small set of islands in Hillsborough Bay.

## DAVIS ISLANDS AND THE DEPRESSION

Though far removed from the scene by 1930, Davis's influence, and that of his plans for Davis Islands, was still followed by Davis Islands Incorporated and its resident vice-president, Lauriston G. Moore. Working on the Davis Islands development since 1925, Moore served as director of the contract department for D.P. Davis Properties. When Stone & Webster purchased the

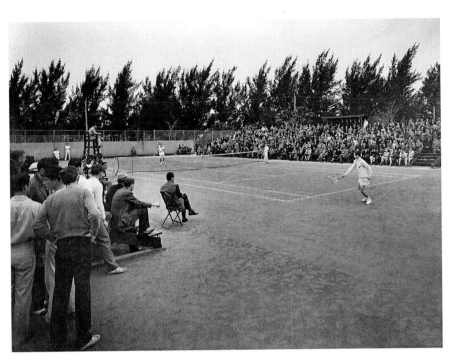

The Dixie Tennis Tournament was one of the most enduring events on Davis Islands. The clay courts of the tennis club hosted the tournament for years, drawing players and spectators from across the state and the country. *Courtesy of the Tampa Bay History Center Collection.*

islands from Davis, it kept Moore, who would serve the company in various capacities, including vice-president from 1931 until 1945. The company also retained Edith Davis (no relation to David), who was the office manager for D.P. Davis Properties and Davis Islands Incorporated from 1925 until her death in 1952.[150]

When Moore assumed the vice-presidency of Davis Islands Incorporated, a position that included site management for the absentee owners, the entire property consisted of 115 structures, including 92 homes, 11 apartment buildings, 2 hotels and 10 commercial and public buildings. Of the fifty-one streets that currently run through Davis Islands, only seventeen were listed in the 1931 city directory, indicating that the remaining thirty-four had not been completed. While the Spanish, Italian and Mediterranean Revival styles still dominated the built environment, some less extravagant styles began emerging, with the approval of Davis Islands Incorporated. The most prevalent of these new styles was red brick, with the Kornell Apartments building, located at 25 Davis Boulevard, as the prime example. Built in

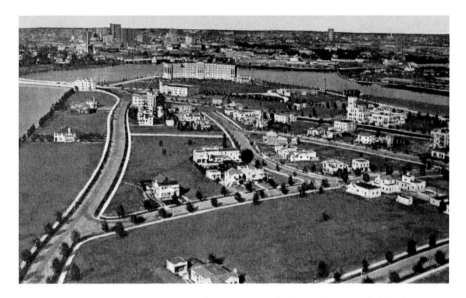

This aerial postcard view of Davis Islands was produced during the 1930s. While the postcard is accurate as to the number and location of homes, apartments and Tampa Municipal Hospital, the color is very misleading. Sand was still quite predominant on the islands, but it was colored to look like grass in this view. *Courtesy of the Tampa Bay History Center Collection.*

1928, the two-story, box-shaped building represents an era on Davis Islands when less expensive building materials and simpler construction techniques dominated blueprint pages.[151]

Despite the slumping real estate market, work continued on the Davis Islands project, which was beginning to emerge from the wreckage wrought by the collapse of the Florida land boom. By the mid-1930s, this recovery was felt in small pockets around the city of Tampa and the state of Florida. As a result, definite improvements could be seen by 1936. By this time, only nine Davis Islands streets remained absent from the pages of the city directories, and work progressed on the new airport at the end of the islands. Growth in the real estate market continued at a slow pace during the first half of the 1930s, with the addition of only nine homes and one hotel. A caddy shack and pro office for the development's nine-hole golf course also added to the slowly climbing building tally.[152]

One of the biggest building projects on the islands, perhaps second only to Tampa Municipal Hospital, was the construction of the "Downtown Airport," begun in June 1934. The airport soon received a new name—Peter O. Knight Airport—in honor of the savior of Davis Islands and one of the most influential

Tampans of that or any time. The project, one of many funded by the Works Progress Administration (WPA), occupies the southeastern end of the islands. Though first proposed in 1930, the idea did not become reality for another four years.[153]

The airport, operational in early 1937, barely produced a profit during its first year. According to the Hillsborough County WPA office's year-end report for 1937, revenues at Peter O. Knight Airport totaled $195, derived mostly from hangar rentals. In contrast, Drew Field, Tampa's other airport, brought in $2,131. To boost revenues, city leaders planned a $500,000 expansion to the small airport. The project would begin "as soon as the WPA is ready," according to Tampa mayor R.E.L. Chancey. The expansion would include dredging more land for a longer runway and closing off one of the islands' original canals, which cut through the western edge of the airport.[154]

The terminal, covered in Florida limestone, would not age well but, at the time, was considered a sight to behold. City officials named the building the Tony Jannus Administration Building, in recognition of the pilot of the world's first scheduled commercial airline flight (which took place January 1, 1914, from St. Petersburg to Tampa). The 1939 book *Florida: A Guide to the Southernmost State* hailed the newly opened complex:

> [The administration building], *completed in 1938,* [an] *outstanding structure at the airport, is a two-story stone building faced with key limestone blocks and ornamented with coping bands of glazed black tile. The sawed surfaces of the limestone blocks, quarried on the Florida Keys, reveal cross-sections of shellfish, sea plants, and coral formations. An open balcony extends entirely around the second story of the building. The third story is formed by an octagonal, glassed-in observatory, above which a glass and metal lantern, designed to represent the lamp room of a lighthouse, supports an aerial beacon.*[155]

The guidebook points out that "the rotunda walls are decorated with seven murals by George Hill of St. Petersburg." Hill, a noted WPA artist, painted seven scenes relating to the history of aviation, including Archimedes, Icarus and Daedalus, the Wright Brothers, Otto Lilienthal, the Montgolfier Brothers and two of Jannus—one titled "Tony Jannus in Russia" and the other "History's First Scheduled Airline Passenger Arrives in Tampa."[156]

Davis Islands seemed, during its early years, to be the perfect location for civic and government leaders to spend public funds. The construction

The administration building at Peter O. Knight Airport was constructed as part of the WPA during the Great Depression. Workers used limestone for the exterior walls, which looked attractive but eventually began to disintegrate. The building had to be replaced in the 1960s. *Courtesy of the Tampa Bay History Center Collection.*

of the hospital and Peter O. Knight Airport are two examples. The late 1930s saw the beginning of another public project, one that would have converted most of the southern end of the islands with a park and museum commemorating the Spanish-American War. Property for the project, located on the waterfront near the airport, was acquired by the City of Tampa, Congressional support was sought and granted and plans were drawn for a $500,000 building and memorial park encompassed by forty acres of land. Delays soon set in, and like many projects begun at the cusp of the 1940s, the project never materialized. Ironically, a museum and park commemorating one war, and the veterans of that war, was delayed and ultimately abandoned to support the men and women fighting in another war: World War II.[157]

As Tampa emerged from the 1930s, even with world war looming on the horizon, life was beginning to improve. The *Tampa Daily Times*, on March 15, 1940, pointed to the increase of housing construction throughout Hillsborough County as an indicator of better times, stating that "building in Tampa and Hillsborough County is at a new post-boom peak." The paper was quick to point out that the statistics did not include "big government building programs, including slum clearance projects here." At the end of

1940, a *Daily Times* headline announced a "13-Year High Reached Here In Building." The story explained that, in the first eleven months of 1940, 287 homes had been built in the City of Tampa.[158]

The people of Davis Islands felt the effects of the city's growth. By 1941, the islands included 175 homes, 15 apartment and hotel buildings and 13 commercial and public buildings, for a total of 203 structures. The growth of the housing market on the islands, with 74 new homes built since 1936 (most of which were built in the later 1930s), extended into previously unoccupied territory. Streets in the lower half of the islands, such as Marmora, Severn, Erie and Lucerne, started to receive attention from homebuilders. Tampa Municipal Hospital still dominated the landscape of Davis Islands. The Gordon Keller School of Nursing built its new home next to the hospital in 1936, expanding the hospital's role to that of an educational institution. In 1937, Tampa Municipal was one of two hospitals in the nation using electroshock therapy. The hospital stood, on the eve of the Second World War, ready to grow, but it needed another spark.[159]

# WORLD WAR II COMES TO DAVIS ISLANDS

World War II brought a variety of benefits and liabilities to Davis Islands. One of the primary concerns of local and military leaders during the war concerned the housing of soldiers in the city for training. Davis Islands's apartments and hotels, particularly the Mirasol and the Mirasol Plaza (formerly the Palmerin) hotels, accommodated some of the city's newest military residents. Davis Islands Incorporated's Moore, too old to serve in the military, still contributed to the war effort by serving on Hillsborough County's rationing board.[160]

Among the most pressing concerns early in the war was the question surrounding the future of Peter O. Knight Airport. The army air corps had taken over two of Tampa's municipal airports, Drew and Henderson Fields. Peter O. Knight then became the only airfield in Tampa available for commercial and private planes. This did not protect the field from closing "for the duration," which was seen as a method of securing the area and reducing the number of airplanes appearing in local skies. The main drawback to the closure plan, though, was the elimination of civilian air travel in a large portion of the Tampa Bay area. The Tampa Aero

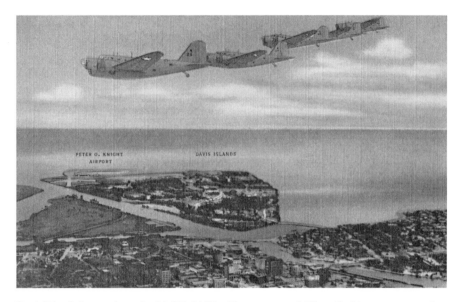

Davis Islands is prominent in this World War II–era postcard. Though this same postcard can be found with different cities superimposed beneath the airplanes, this still would have been a common sight during the war due to the three airbases in the area: Drew Field, MacDill Field and Henderson Field. *Courtesy of the Tampa Bay History Center Collection.*

Club mounted a campaign to save the airport, which proved successful. Passenger and private planes continued to use Peter O. Knight Airport throughout the war.[161]

As pro-airport advocates correctly predicted, Peter O. Knight gained importance due to its role as the only public airport available and its proximity to downtown, but its deficiencies also began to show. It seemed apparent as early as 1943 to some of the area's aviation boosters that the islands' airport was too small for the larger passenger planes. People such as Roslyn Burritt, who championed the saving of Peter O. Knight Airport, now wanted Henderson Field, near Temple Terrace in northern Hillsborough County, to be the county's international airport when the war ended. County leaders began constructing Henderson Field before the United States became involved in World War II, but the war department intervened before construction could be finished.[162]

Neither Peter O. Knight Airport nor Henderson Field became Tampa's international airport. Drew Field, in existence since the 1920s and expanded by the army air corps during the war, became Tampa International Airport in 1947. Peter O. Knight currently serves small, private planes. Remnants

of Henderson Field's asphalt runways are barely visible amid the tourist meccas of Busch Gardens and Adventure Island.

While Allied forces raced through Europe, giving the people of the United States a sense that an end to the war in Europe was near, things began to stir on Davis Islands. On January 10, 1945, Mr. and Mrs. Melvin Hudson purchased one of the islands' original hotels, the Mirasol Plaza Hotel, located at 115 East Davis Boulevard, plus three rear lots that fronted on Columbia Drive. Previously known as the Palmerin (and not to be confused with the Mirasol Hotel, 84 Davis Boulevard), the hotel soon became known as Hudson Manor. The hotel featured fifty-two rooms, each with a bath, and "was filled with guests" at the time of the purchase. The former owner, Dr. Sherman Smith, owned another set of 1920s boom–era properties in the area, Temple Terrace Estates, which he had sold to Florida Christian College earlier in 1945.[163]

Events on the other side of the globe quickly grabbed headlines in the middle of 1945, culminating with the news that Japan had surrendered on August 14, 1945, ending World War II. Closer to home, W. Howard Frankland, owner of Tampa's Pioneer Tire Company, began to acquire a real estate empire consisting mostly of 1920s properties in downtown Tampa. His investment company, Crest View Realty, purchased the Wallace S. Building, the Stovall Office Building and the Haverty Furniture Company Building in February 1945. These procurements were small in comparison to his takeover, with three partners, of Davis Islands Incorporated on October 22, 1945. The sale encompassed "the stock of the corporation and its realty, consisting of between 800 and 1000 lots on the island, as well as the Davis Islands Country Club."[164]

The ownership group, which retained the services of Lauriston Moore, included J.H.L. French, Wallace C. Tinsley and Alfred Dana, in addition to Frankland. Two of the members, Tinsley and Dana, already owned buildings on Davis Islands: Tinsley co-owned the Mirasol, and Dana owned the Venetian Apartments. The *Morning Tribune* reported that "the new owners plan to begin construction on 100 or more new homes, ranging in price from $7,500 to $15,000 or above, when materials become available."[165]

Despite the rationing of building materials and restrictions placed on nonmilitary-related construction imposed by government leaders during World War II, housing growth continued on the islands even during the war, possibly with the help of Moore's position on the county rationing board. Seventy homes were constructed between 1941 and 1946, a figure virtually identical to the 1936–41 period. While many of these homes were

constructed after VJ Day, most came about during the war years. One important difference between the late 1930s and the early 1940s was the absence of commercial building on Davis Islands. All construction focused on residential structures, with the exception of the opening of two more streets, Jamaica and Riviera.[166]

World War II also brought some less immediate yet far-reaching benefits. Among those were great advances in medicine, which manifested locally in Tampa Municipal Hospital and its capacity as a teaching facility. An internship program, started during the war, produced the next generation of Tampa physicians. Perhaps most importantly, the war brought people to the area—a lot of people. The influx of men and women during the war proved small compared to the population boom that would soon impact the area.[167]

With the end of the war and a change to local ownership, Davis Islands was poised to begin another boom. The development, born in the fearless days of the Roaring '20s, endured an awkward puberty in the lean years of the Depression and global war. The islands emerged from World War II ready for opportunity. Now in its twenties, the project was entering the next stage in its life. It was about to find a new batch of residents, and many would carry a distinctive Latin accent.

## TAMPA'S LATIN COMMUNITY FINDS DAVIS ISLANDS

While documenting the family history of a Latin couple living in Ybor City in 1939, Stetson Kennedy learned that the people of Tampa saw Davis Islands as a different, even unattainable place to live. Kennedy quoted a conversation between Amanda and Enrique, a middle-aged couple he was visiting while with the Federal Writers' Project. He and his wife took the Ybor City couple on an evening drive through Tampa, and the Tampeños talked to the writer about the city. "'This is Davis Island,' says Amanda. 'This is where all the millionaires and rich people live. It's very pretty in the daytime but we can't see much now.'"[168]

Amanda and Enrique represented the old guard of Ybor City. Enrique was a cigar maker, making him a member of a dying profession. The Great Depression made matters worse for cigar makers like Enrique. While the Depression gripped the entire Tampa community, it hit Ybor City particularly hard. "During the 1930s, [Ybor City's] vigorous

institutional base fell into serious decline, eroding the bonds that connected the Latin population."[169] Historians Gary Mormino and George Pozzetta assert that "by 1935 cigars no longer supplied economic prosperity to Ybor City." Mormino and Pozzetta pointed out that Latins were slow to move away from the enclave. The authors examined one thousand Latin names, randomly selected from the 1935 Tampa City Directory and found that "fully 97 percent of Tampa's Latins resided in Ybor City or West Tampa." Further examination of selected streets in Hyde Park and Seminole Heights showed little "Latin intrusion into those residential areas."[170]

The same statistics from Hyde Park and Seminole Heights generally applied to Davis Islands in the mid-1930s. Only 2 Latin surnames appear among the 101 homeowners listed on Davis Islands in the 1936 Tampa City Directory, which is actually a reduction by 2 from the 1931 directory, where 4 out of 92 homeowners had Latin surnames. This began to change in the late 1940s, when the development experienced a second land boom. Among the hundreds of new residents of the neighborhood were Latins who formerly called Ybor City and West Tampa home. Mormino and Pozzetta documented this exodus from the long-standing Latin communities and observed that World War II "served as the great watershed" where "Ybor City's youth and men volunteered in droves for the American cause, and for the first time in the colony's history large numbers of second-generation ethnics left the old neighborhood."[171]

When the veterans returned from the front lines, they discovered their old neighborhoods had changed, and not for the better. "Ybor City's housing stock was crumbling even before the war. Ray Grimaldi, an Ybor City banker, remembered how the neighborhood had transformed during the war years: 'The area had deteriorated tremendously and people started moving out...like we moved out in 1950...All the young kids who had gone in the service and to college...were leaving Ybor City.'" Many who left Ybor City found a home on Davis Islands.[172]

Miguel and Grace Díaz arrived on Davis Islands in 1946, moving from their home on Columbus Drive shortly after the conclusion of World War II. Miguel, the president of Tampa Crown Distributing, a large liquor distribution company, and his wife were among the first Ybor Latins to move onto Davis Islands after the war, buying a home at 464 West Davis Boulevard. Their daughter Anna, with her husband, Charles Pérez Jr., also decided to live on the islands, staying with her parents while their home (456 West Davis Boulevard) neared completion.[173]

Lawrence and Gloria Hernandez moved onto Davis Islands at about the same time as the Díaz family. The Hernandezes were the proprietors of one of Ybor City's most famous and enduring symbols of the Latin Quarter's heritage: the Columbia Restaurant. Another member of the Hernandez family, Adela, and her husband, César Gonzmart, too, called Davis Islands home in the 1950s.[174]

Another young couple to move to Davis Islands was Anthony and Josephine Pizzo. Like the Díazes and the Gonzmarts, the Pizzos were part of a new generation of Ybor Latins. Mormino and Pozzetta noted that "by the 1960s large numbers of second- and third-generation Latins had graduated from universities, entered the corridors of power, and moved away from Ybor City." The Pizzos, who both graduated from Florida colleges, moved to a new home on Lucerne on the islands in 1950 from an apartment on Twenty-second Avenue in the South Ybor City–Palmetto Beach area. Anthony, who served briefly (and stateside) in the army during World War II, worked as the sales manager for Tampa Wholesale Liquor, and Josephine taught at Philip Shore Elementary School, located in their former neighborhood.[175]

Other new arrivals to the islands included the vice-president of Ybor City's King-Greco Hardware, Dick A. Greco Jr., and his wife, Dana. Greco, who would become mayor of Tampa in 1967 and again in 1995, related that he and his wife first moved into "new apartments on Danube that a friend of mine built" in 1960. By 1961, the young couple lived in a house on Luzon. "One of the reasons I liked living on Davis Islands was that you could move up without moving too far." The Grecos' experience on the islands demonstrate this masterfully. They went from an apartment on Danube to a 1,700-square-foot home on Luzon to a 2,600-square-foot home, located on Ladoga, within a nine-year period. It appears that by the 1950s, the Latin families on Davis Islands attained what seemed only a dream for Amanda and Enrique and many other Ybor City residents of a previous generation.[176]

The dream of a new home enticed many people, both longtime residents and new arrivals, to build on Davis Islands. Over two hundred homes were constructed on Davis Islands between 1946 and 1951. In addition, eleven apartment buildings, four townhouses and two commercial buildings sprang from the sandy ground. This phenomenal growth flourished from an even larger trend felt across the city and state. Home-buying statistics for 1950 showed that "more Tampans bought homes and business property during 1950 than ever before in the city's history," amounting to a total of $53 million in sales citywide.[177]

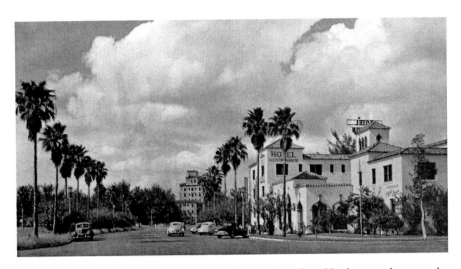

East Davis Boulevard still had a fair amount of vacant lots when this photograph was made in the 1950s. The Hotel Hudson Manor, formerly the Palmerian Hotel, is on the right, and the Mirasol is in the center background. Both structures are still in use today. *Courtesy of the Tampa Bay History Center Collection.*

While some Latins found moving to Davis Islands a natural move up the economic ladder, other members of Tampa society were still prohibited from buying—or even renting—on the islands. Restrictive covenants were placed on all Davis Islands property, barring people of African descent from buying land on or leasing land from a property owner on Davis Islands. These restrictions would be outlawed in the coming decades, but the stigma remained for many years.[178]

Two significant figures in the history of Davis Islands passed away in the early 1950s. Lauriston G. Moore, who worked on the Davis Islands development for a quarter of a century, died April 12, 1950, at his home on Aegean on the islands. His contributions toward the development and, at times, survival of Davis Islands should not be forgotten. Edith Davis provided an even more remarkable example of job loyalty. Mrs. Davis worked for the various Davis Islands companies almost from beginning to end. She passed away on December 26, 1952. She, too, left this earth from Davis Islands, dying in her son's home on Channel Drive.[179]

## MIDCENTURY DAVIS ISLANDS

The city retained ownership of the land previously earmarked for the Spanish-American War Memorial Park and Museum, and the nonexistent complex appeared on Tampa street maps into the 1940s. Finally, on August 10 and 11, 1954, the city auctioned off these lots, contributing to the remarkable growth of private real estate on the islands. At the conclusion of the two-day sale, fifty-six of an available seventy-three lots were sold for a total of $173,440. The city held another fifty-five lots, which it planned to sell in the near future. This by no means could compare with the boom days of yesteryear, but the event still proved significant. All the lots sold brought in at least their appraised value, and many made the city considerably more. While builders and real estate agents purchased some of the land to turn around and resell, the majority of the lots were bought by prospective homeowners looking to live on the islands.[180]

At about the same time that the city was divesting itself of its residential holdings, Davis Islands Incorporated was doing the same thing, ending an almost thirty-year presence on the islands. W. Howard Frankland, president of the company since he and his partnership group purchased the development in 1945, had finished what started with D.P. Davis in 1924 and promulgated under L.G. Moore in the 1930s and 1940s. Construction of an expanded business district, growth in the multifamily segment of the islands' real estate market (represented mostly in rental properties) and the completion of long-standing infrastructure projects occurred under Frankland's Davis Islands Incorporated. The development's few remaining empty lots rested in the hands of a small number of developers and private land owners while city and county agencies owned the public buildings and lands.[181]

The end of Davis Islands Incorporated did not mean the end to growth on the islands. Quite to the contrary, both residential and commercial construction sped along on newly paved roads, riding into the 1950s and '60s. Construction within the business district came fast and often along East Davis Boulevard between Barbados and Chesapeake. What had always been set aside for commercial use finally stirred from a long hibernation.[182]

D.P. Davis built only one commercial building dedicated to retail amenities during his ownership and development of Davis Islands. That building, Bay Isle, was designed by noted Tampa architect M. Leo Elliott. Located at 238 East Davis Boulevard, the Bay Isle building remains the anchor of the islands' business district. In the early 1950s, though, it stood alone amid a sea of sand and slowly maturing palm trees. Other less attractive, if more functional, buildings eventually joined the landmark on East Davis

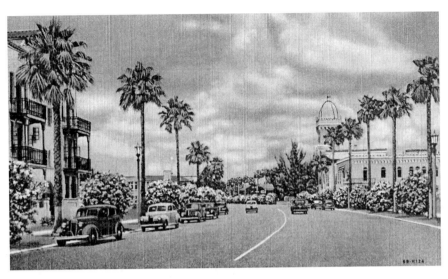

The scene pictured in this postcard, which is postmarked 1952, is not much different than if one were to look north along Davis Boulevard today. The Ritz Apartments on the left, Palace of Florence on the right and Kordell Apartments (now an office building) in the center are all still standing, as are the palm trees that line the boulevard. *Courtesy of the Tampa Bay History Center Collection.*

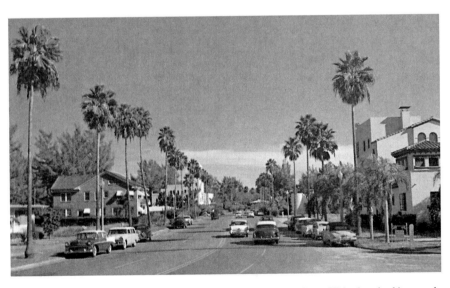

Davis Boulevard was a popular subject for postcard photographers. This view, looking south from the intersection with Adriatic, shows Davis Islands much as it is today. Note the white concrete, obelisk-style street marker on the right of the frame. *Courtesy of the Tampa Bay History Center Collection.*

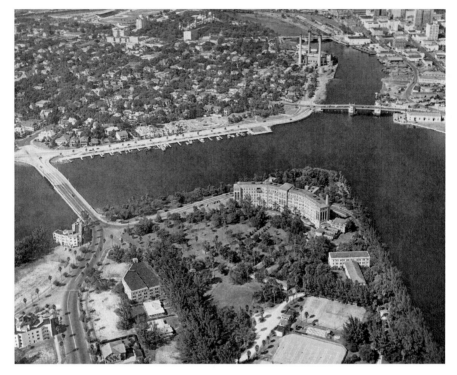

The proximity of Davis Islands to the rest of Tampa is clearly seen in this 1950s aerial photograph. Tampa Municipal Hospital, which would soon be renamed Tampa General Hospital, is still its original size, and the tennis courts to the south are readily seen. The original bridge and the Venetian Apartments are also still standing. This view would look radically different twenty years later. *Courtesy of the Tampa Bay History Center Collection.*

Boulevard, starting with 230 and 232 East Davis, constructed between 1950 and 1951. By 1956, there were twenty-six business addresses along East Davis Boulevard, including two automobile service stations. These buildings, which together constituted what amounted to a small strip mall, offered a clothing store for women, a toy store, a pharmacy, a hardware store and a variety of other shops.[183]

Municipal additions to the islands included a fire station—Tampa Fire Department's Station Number 17, which opened on the islands in 1958—and an addition to the hospital, also completed in 1958. The hospital renovation, the first of many that would greatly increase the institution's size, overwhelmed the original building, obscuring its north face from view.[184]

Despite its grand beginnings, the golf course eventually fell into disrepair. In the early 1950s, a young *Tampa Tribune* reporter named Leland Hawes played on the Davis Islands golf course. In speaking of the course years later, Hawes recalled that it was not in very good condition, to say the least. By that time, the Davis Islands golf course was public and owned and operated by the city. Though not necessarily neglected, the course did not receive the same attention it did as a private, members-only course.

With the returning prosperity of land sales on Davis Islands, new home construction under the GI Bill and the advent of affordable home air conditioning, the postwar boom in part completed what the 1920s land boom had started. All this meant that land on Davis Islands was again marketable, and a nine-hole golf course was expendable in the face of potential profits.

Another, more ominous, theory exists to explain the course's demise—the idea that, with continued successes of the civil rights movement, African Americans would have to be allowed to play on the city-owned course. The Davis Islands course was the only municipal course during this time that ran through a white residential neighborhood, which potentially could explain this idea. Again, this is just a theory with no supporting evidence.

Whatever the reason, the Davis Islands golf course was transformed into the Byars Thompson addition to Davis Islands in the mid-1950s, with hundreds of homes appearing on the former fairways, greens and sand traps. The Davis Islands Country Club transitioned into the Davis Municipal Building (455 Bosphorous) and, by 1966, was demolished, too. The sole surviving building, the incongruently named "19th Hole" cantina, was converted into a private residence. However it, too, succumbed to the wrecking ball in 2013.

Construction of commercial buildings on East Davis Boulevard coincided with a larger pattern of building on the south side of Davis Islands. South Davis Boulevard, nonexistent before the mid-1950s and absent from directories until even later, became festooned with work trucks and building materials during the late 1950s and early 1960s. Other streets, such as Hudson, Itasca, Ladrone, Madeira, Martinique and Rhine, blossomed in a similar fashion in a matter of a few years, after lying virtually dormant for decades. This rise in construction pushed the total housing inventory on the islands to 861 in 1956.[185]

Most of the houses constructed during this era reflect the architectural tastes of the time, not to mention the removal of the approval process established by Davis and continued, with revisions, through Frankland. Single-story, ranch-style homes became the norm, with a lesser number of

multistory, wood-frame homes joining them. Some homeowners opted for the more compatible Mediterranean Revival–style homes reminiscent of Davis Islands's 1920s heyday. All these housing styles also appeared on lots on the "older" streets of the islands, filling long-standing gaps between homes. By 1961, roughly 74 percent of the current buildings on Davis Islands had been constructed.[186]

Peter O. Knight Airport continues in its role of serving the private aviation traffic of the City of Tampa. The original limestone-clad building was demolished in the 1960s and replaced by a low-slung concrete block building. The seaplane basin, long an asset for the airport, is now filled with sailboats, moored for the members of the nearby Davis Islands Yacht Club, founded in 1955.[187]

Davis Islands could no longer be considered just a residential community as it entered the 1960s. Nor could it be considered a community consisting solely of homeowners. In 1961, Davis Islands contained sixty-one apartment buildings, a dramatic increase from the 1956 figure of thirty-six. The number of homes on the islands also increased sharply, shooting past the 1,000 mark to 1,375.[188]

Part of the deal Davis made with the City of Tampa to receive the right to build Davis Islands was that he would build a bridge that would cost at least $150,000. The bridge, along with a vast park, was linked to Davis's financial agreement. Davis lost the islands and his life before the bridge was completed, but when it was finished in 1928, it was cause for celebration. Nearly forty years later, though, the bridge was cause for concern. The two-lane bridge could not accommodate the increased traffic volume going from Bayshore Boulevard onto the islands. The only solution, so city leaders thought, was to build a new bridge. In fact, two bridges were built in place of the original stylized one. In addition to the loss of the first, more aesthetically appropriate bridge was the demolition of the Venetian Apartments, which stood at the foot of the bridge across from the hospital, to make way for the new bridges. The Venetian Apartments building was one of the original structures designed for the islands, and one of the first and only large commercial structures lost. New bridge construction could not be avoided, and options were limited regarding bridgeheads on both the Hyde Park and Davis Islands sides. By the time the new bridge was built, there were a growing number of medical offices on the east side of Davis Boulevard, making a more northerly and easterly land fall for a bridge an impossibility. Additionally, one of the property owners on Hyde Park Avenue refused to sell his home to the city for construction of the island-

bound span. Engineers were forced to design the bridge with a fairly sizeable curve around the property. The homeowner received covered parking under the bridge, but his view of Hyde Park Avenue was exchanged for one of a concrete onramp.[189]

A devastating fire gutted the once-venerable Davis Islands Coliseum, formerly located at 90 Chesapeake, on the corner of Chesapeake and Danube. On the evening of January 26, 1967, the dark night skies turned a brilliant orange-red with the out-of-control blaze. The fire, which started at around 9:30 p.m., occupied most of the Tampa Fire Department's force. Fourteen units, twenty-three fire trucks and over one hundred fire fighters battled the blaze from 10:40 p.m. until well past midnight. There was little fire fighters could do since the building had burned undetected for over an hour. Flames and smoke, which reached "hundreds of feet" into the sky, could be seen as far away as Sulphur Springs to the north and St. Petersburg to the southwest.[190]

The building was only forty-two years old, but it was a full forty-two years. Once a popular facility with a full social calendar and promising future, the old coliseum was already considered obsolete before its fiery demise. Harry J. Warner and Carl Moseley owned and operated the coliseum from 1940 until the early 1950s, when Moseley likely sold his interest to Warner. The building's most popular and lucrative attraction during this time was a skating rink. Moseley briefly installed an ice-skating rink and hosted a traveling ice-skating show in the early 1950s. Additionally, entertainers of all kinds included the coliseum on their tour itinerary. Musicians such as Guy Lombardo, Xavier Cugat and Harry James, plus performers from the Grand Ole Opry, all played at the coliseum. Warner sold the building in 1963 for $100,000, and the rink gave way to a bowling alley and cocktail lounge. The new owners defaulted on their loan from Warner, and he took back the building two years later.[191]

With his resumption of ownership, Warner had a new idea for the old coliseum: a grocery store. The city, however, refused to change the zoning from residential to commercial. He next offered to sell the building to the city for $100,000 for use as a city recreation building. The city refused this as well, and the building sat empty for the next year and a half.

It took only a few hours to erase a structure built on forty-two years of memories. Joe Gomez, the city's fire marshal, ruled that vandals caused the fire. Warner reported that he'd had to repair several acts of vandalism over the past few months. The fire attracted close to one thousand onlookers from all parts of the city. The *Tampa Tribune* reported that, despite the high volume

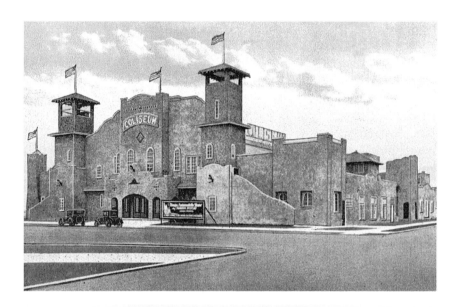

of cars pouring onto the islands, the new bridges handled all of the traffic without incident.

One problem that did arise, though, was the countless numbers of burning embers that were spread across the neighborhood. Through the valiant efforts of the Tampa Fire Department, aided by residents with garden hoses, no other buildings were lost during the blaze. The remnants of the burned-out building continued to smolder well into the next night. The memories of the long-lost Davis Islands Coliseum still smolder within Tampa residents to this day.[192]

Despite all this, or perhaps because of it, the islands still held a mystical value. Born on Davis Islands, Rebecca Pérez, whose parents and grandparents moved onto the islands in the 1940s, carries fond memories of her old neighborhood. "I remember Gasparilla—we would go to the street...that runs along the canal [Channel Drive] and watch most of the fathers of my school pals dressed as pirates with cannon firing." She also reminisced about the islands development's precarious placement in Hillsborough Bay, making it particularly vulnerable to strong storms. "I remember before the bridge as it is now, that during especially violent storms the original bridge was closed and we didn't have to go to school." Her family received orders to evacuate the islands in the face of three separate storms during her childhood, but, she says, "We never left."[193]

Someone who had no choice but to leave as a child decided to come back to visit as an adult. David P. Davis Jr., thirty-one years old at the time, came to Tampa in 1953 to visit family, including his aunt and uncles. He also wanted to see Davis Islands for the first time in twenty-seven years. Davis only had faint memories of his father and his developments, saying, "It is like trying to piece together the hazy fragments of a vague dream."[194]

*Opposite, top*: The Davis Islands Coliseum, completed in 1925, was the largest project Davis originally conceived for the islands development. Located on Danube, the Coliseum was destroyed by fire in 1967. *Courtesy of the Tampa Bay History Center Collection.*

*Opposite, bottom*: Roller-skating was extremely popular during the 1940s and '50s, and the Davis Islands Coliseum was home to the Coliseum Skating Rink. The large, wide-open space was perfect for skaters, from novices to experts. The coliseum owners even tried ice-skating in their building, which also proved to be a success. *Courtesy of the Tampa Bay History Center Collection.*

Without knowing it, David Davis Jr. described the burden that weighs on all his father's biographers. The legends surrounding his life and death are a tangle of public relations stories, selective memory, honest mistakes and outright lies. Sorting through it all and "piecing together" those "hazy fragments" into a coherent history is difficult indeed. Once complete, the substance of the man and the impact he made on his native state are a far cry from a vague dream.

# DAVIS ISLANDS TODAY

The hazy dream felt by D.P. Davis Jr. when looking back on his childhood was in stark contrast to the bright future that Davis Islands was looking toward in the second half of the twentieth century. By the 1960s and early 1970s, many of Tampa's older neighborhoods, once viewed as fashionable places to live, had started a steady decline. Working-class neighborhoods like Ybor City and West Tampa had felt these effects as early as the late 1940s following the end of World War II. Other neighborhoods, such as Hyde Park, Tampa Heights and Seminole Heights, withstood the early population loss to the growing suburbs. Road construction and continued suburbanization eventually took its toll, but not everywhere. Davis Islands seemed somehow immune and was not suffering the same fate as Hyde Park, long believed to be the place to live in Tampa. Despite its proximity to mainland Tampa, Davis Islands remained isolated and insulated from the blight encroaching in to other neighborhoods in the city. Two theories may help explain this phenomenon. One is the mental and visual barrier of the water. Some have described Davis Islands as "the best gated community in Tampa," with the water, of course, acting as the gate. While an interesting thought, it falls short of a full explanation.

A stronger theory lies in the fact that the most striking difference between Davis Islands in this era as compared to other parts of Tampa as old or older is that Davis Islands did not have any large-scale demolition and rebuilding projects to rip through its streets, as did Hyde Park, Ybor City, West Tampa, Tampa Heights and Seminole Heights. Urban renewal and the construction

of the crosstown expressway and the interstate system wrought immense havoc on these once proud neighborhoods. While some speculate, from the vantage point of the twenty-first century, road projects such as the crosstown expressway, now the Selmon Expressway, were good for Hyde Park, there could hardly have been a worse prescription for the ails of these historical districts at the time. None of these disruptions, urban renewal or highways, touched Davis Islands, and people, particularly upwardly mobile whites and Latins, continued moving onto the islands. Some bought and maintained older homes while others obtained lots and built new homes. The high number of vacant lots may also have contributed to Davis Islands not succumbing to the same problems as the older neighborhoods. Other 1920s-era developments in Tampa, including Beach Park and Bel Mar, had vast amounts of vacant land and actually improved during this time. Some historic homes were razed to make way for new construction, but the older housing stock survived the onslaught of people fairly well. Two particular historical features, the Venetian Apartments on the northern end of the islands and the original bridge, did not last through the 1960s, but their demise was directly related to the growth of the islands.

A distinct feature of the islands, but one that is often overlooked, is the presence of the Davis Islands Yacht Club on the southern end of the islands. Its address, 1315 Severn, is little known and lesser used. One is as likely to use its map coordinates: 27° 54.47 N, 82° 27.09 W. There is only one road to the yacht club, and it carries cars, bicycles, joggers and skaters down by the airport, past the boat ramps and "beer can beach" and on to the private club's entry gates. Once past the gates, the visitor soon finds out why the club's motto is "the Sailingest Club in the South."

# GROWTH AND CHANGES ON DAVIS ISLANDS IN THE 1980s

Davis Islands has experienced several periods of growth during its almost ninety-year history. One of the more important spurts occurred during the 1980s, when expansion first had a significant impact on its original building stock. Though Tampa General Hospital provided the main impetus for change, other projects left lasting impressions on the landscape of Davis Islands.

Tampa General Hospital has brought more prosperity, and more controversy, than any other institution on Davis Islands. Opened in 1927

Two country club buildings were constructed on Davis Islands. This one, the tennis club building, sat at the northern end of Marjorie Park and served as the clubhouse for the tennis courts for decades. It was eventually demolished to make room for a parking garage associated with Tampa General Hospital. *Courtesy of the Tampa Bay History Center Collection.*

as Tampa Municipal Hospital, Tampa General first expanded in the mid-1950s. By 1980, the hospital was again too small for the county's burgeoning population. The hospital authority released plans for an expansion to the hospital, which would more than double the facility's capacity.

Though considered a world-class hospital, Tampa General is not without its problems. It seems no one gave too great a consideration to the piece of land the new hospital occupied, aside from the fact that the city already owned it. The location on an island accessible by only one bridge (two at present) would prove to be vulnerable during hurricane season, with evacuations not uncommon. Finally, after Tampa's close encounter with Hurricane Elena in August 1985, the hospital's main generator was moved from the ground floor to a higher and safer location. At present, the hospital can withstand the strongest of storms. Yet the risk of the islands' bridges washing out, thereby isolating the hospital from the rest of the city, remains.

Today's Tampa General is a modern, 1,018-bed facility, with 43 surgical suites and six thousand employees. Over forty-four thousand patients are admitted and over five thousand babies are born at Tampa General every year. In addition, the emergency room handles over eighty thousand patients yearly. Though not originally intended for Davis Islands, Tampa General Hospital has become a major force, both on the islands and in the City of Tampa.

The growth and economic impact of the hospital has had a physical impact on the islands. The most obvious, when viewing the islands from the air, is the extension of land north into the channel to physically support the growth of the hospital. Expansion to the south and the addition of several parking garages have also changed the landscape. The hospital, always a presence in Marjorie Park, has grown farther into the park. The original tennis club building was demolished, as was the Gordon Keller nursing school. While the school is no longer on the islands, the city built a new tennis complex named in honor of former mayor, former child tennis star and former islands resident Sandra Freedman.

# DAVIS ISLANDS IN THE TWENTY-FIRST CENTURY

Davis Islands sat, at the turn of the twenty-first century, where it had been for the past seventy-five years—as a symbol of consistent prosperity in a sometimes-stormy sea of booms and busts. The first five years of the 2000s saw another surge in Florida real estate, with values rising to staggering heights. Many homes on the islands changed hands, but remarkably few of the original 1920s homes suffered the unrelenting swing of the wrecking ball that felled older homes across Tampa. The 1950s and '60s ranch-style homes, along with the few empty lots, received the bulk of the attention from demolition and construction crews. Large-scale construction, reignited in the 1980s, continued in the late 1990s and early 2000s as well. New townhomes and apartments, some mimicking the original Mediterranean Revival style, joined the older Med Revs. Demonstrating that Davis's original plan still works, the bulk of the multifamily construction was along or near East Davis Boulevard.

The housing market on Davis Islands was hot. Though construction of two large condominium projects on East Davis Boulevard broadly represents this period of growth, nothing symbolizes the era of extravagance like the home built on the water on Bahama Circle. Two waterfront lots, both with

existing homes, were purchased and combined to create one very large lot for one very large home. Dubbed "the House that Jeter Built," it is the home of New York Yankees's star shortstop and likely future Hall of Famer Derek Jeter.

Not everything has been preserved well on the islands. The city let the Davis Islands pool fall into disrepair and was ultimately forced to close the facility. The Davis Islands pool was renamed in 1965 to honor the memory of Roy E. Jenkins, a man who was "known throughout the South for his keen interest in the youth of Florida and in water safety," according to a *Tampa Tribune* article marking his death. Jenkins, who passed away the year before the city honored him by naming the pool for him, entered the water safety program offered by the Tampa Red Cross in 1923. Jenkins spent a lifetime encouraging both aquatic sports and the Red Cross Lifesaving Corps. He was an honorary director of the Greater Tampa Swimming Association and served for eleven years as an official for the Tampa Invitational Swim Meet.

The Roy E. Jenkins pool is not the only existing historic pool in Tampa. In 2006, the city council bestowed local historic landmark status to the Cuscaden Park swimming pool, which was built in cooperation with the Works Projects Administration during the Great Depression in the northern part of Ybor City. In addition, the city parks department restored the swimming complex, bringing an old gem back to life. The Roy Jenkins Pool in Davis Islands will get the same chance and is scheduled to reopen in 2013 and, more importantly, remain open.

By 2010, the population of Davis Islands stood at around five thousand people. Those residents, and people across Tampa, take advantage of what Davis Islands has to offer every day. Businesses of all kinds had always been planned for Davis Islands, and that plan has certainly materialized. The business district is home to a wide variety of restaurants, professional offices, shops and services. Davis Islands is truly a self-supporting city. Problems still do arise, and this materialized within the business community in 2013. The Davis Islands Chamber of Commerce, founded in 2000, had to disband due to debts brought on by a former board member. In its place stepped the Davis Islands Alliance. Time will tell whether the Alliance will be able to market Davis Islands businesses.[195]

An organization whose future looks bright is the Davis Islands Civic Association. The association has had a steady influence on improvements on the islands throughout the 2000s. Those improvements, such as a dog park, pedestrian trail, traffic calming and neighborhood beautification, have had a dramatic and positive effect on the quality of life for both on- and off-islands

Municipal aviation is still quite popular, and small airports, such as Peter O. Knight, serve the private aviation community in ways that large airports cannot. Originally built with the idea that it would handle passenger and even international plane traffic, Peter O. Knight has settled into a comfortable place in the area's aviation community. *Photograph taken by the author.*

A wide variety of businesses have called the islands home over the years. The business district along East Davis Boulevard was part of the original islands plan, and it is still in use today. This button announces the opening of a new Merrill Lynch office. *Courtesy of the Tampa Bay History Center Collection.*

residents (as people who live on Davis Islands are sometimes differentiated from those who do not live there).

Looking back at the history of Davis Islands, it could appear that the development's success was a foregone conclusion. When we stop to think of the twists and turns, not just of Davis's life but also within the history of Tampa, the fact that Davis Islands even exists, much less prospers, is impressive. What started as a dream advertised with hyperbole has lived up to the hype, offering a timeless lifestyle to residents and visitors. D.P. Davis would be proud, and his family certainly is proud, of what has become of his creation.

# NOTES

## Chapter 1

1. For general information on Florida real estate developers during this period, see Harner, *Florida Promoters*; Nolan, *Fifty Feet*; Doug Stewart, "Madness." For previous biographical studies of David P. Davis, see Covington, "Story of Davis Islands"; Meyer, "Davis Islands"; Kite-Powell, "David Paul Davis'."
2. For an examination of Green Cove Springs and Clay County, see Blakey, *Parade of Memories* and Thomas D. Ryan, *Clay County*. The location of Davis's birth is one of the only constants in all the previous biographies about him.
3. "David Paul Fraser Claimed by Death," undated clipping in Davis family scrapbook.
4. Putnam County Archives, hereinafter cited as PCA, biography of George Mercer Davis, available on the internet at www.co.putnam.fl.us/palatka/tour_files/slide0078.htm. See Daniel L. Schafer, "US Territory and State," in *New History of Florida*, 219 for emigration patterns during this era.
5. PCA, biography of George Mercer Davis; Michaels, *River Flows North*, 89; *Putnam County, Putnam County Genealogical Society Quarterly Journal* (*PCGS*); PCA, marriage book A, 20; U.S. Bureau, Twelfth census, Putnam County. According to the *PCGS*, Collier performed only one other marriage, and no records could be found to establish if he was a Justice of the Peace or a minister or whether or not he had any "authority" to perform marriage ceremonies.
6. U.S. Bureau, Eighth census, Putnam County; *Tampa Morning Tribune*, "Obituary of George Riley Davis," February 14, 1930. See Michaels, *River Flows North* for a description of Palatka in the 1850s.

7. U.S. Bureau, Eighth census, Putnam County. Welaka was misspelled as *Walaka* in the census. Morris, *Florida Place Names*, 149; Lanier, *Florida*, 128.

8. U.S. Bureau, Eighth census, Putnam County. The census data does not list what personal property Davis owned. George Mercer Davis does not appear on the census bureau's 1860 Slave Schedule as a slaveholder. A Nancy Davis is buried in the Westview Cemetery in Palatka with members of the Davis Family. The only date listed is the year of death, 1860. Also, Nancy Davis is not listed with the rest of the Davis family in the 1870 Federal Census.

9. U.S. Bureau, Ninth census, Putnam County.

10. Hartman and Coles, *Biographical Rosters*, 1181; Sifakis, *Compendium*, 16, 25.

11. Foote, *Civil War*, 629.

12. Sifakis, *Compendium*, 25; Foote, *Civil War*, 531–38.

13. Hartman and Coles, *Biographical Rosters*, 1180–81. It is unknown whether the two Davises were related.

14. Kitchens, "Palatka," 150. Kitchens quotes an article from the *Palatka News* dated April 28, 1917, giving Boyd's firsthand account of the incident.

15. U.S. Bureau, Ninth census, Putnam County; U.S. Bureau, Tenth census, Putnam County.

16. U.S. Bureau, Tenth census, Putnam County. Four of the renters were black, including a father and his two daughters. It is impossible to tell at this time if any of them were former slaves of the Davis family, but it is unlikely.

17. U.S. Bureau, Tenth census, Putnam County; *Putnam County*, PCGS. Original in PCA, marriage book B, 168; U.S. Bureau, Twelfth census, Hillsborough County; PCA, marriage book 1, 80.

18. PCA, biography of George Mercer Davis.

# Chapter 2

19. U.S. Bureau, Fourteenth census, Duval County; "David Paul Fraser Claimed by Death," undated clipping in Davis family scrapbook.

20. U.S. Bureau, Twelfth census, Hillsborough County; Nolan, *Fifty Feet*, 192; Civilian Draft Registration, Duval County, Florida, 1917–18. Most sources list David Davis's date of birth as November 1885, with a few giving the precise day as November 29. The only official record obtained thus far that lists his exact date of birth is his World War I draft card. Several attempts have been made to obtain birth and marriage records for David Davis and his siblings. The 1890 Federal Census for Florida was destroyed by fire with the rest of the 1890 census data at the Commerce Department in Washington, D.C., on January 10, 1921.

21. Rambler, *Guide to Florida*, 92.

22. Nolan, *Fifty Feet*, 192 asserts that George Riley Davis grew citrus trees for a living. For an account of freezes throughout the history of Florida's citrus industry, see Mack, *Citrifacts II*, 125–27. For a general history of Florida during this time, see Proctor, "Prelude," in *New History of Florida*. George Riley Davis's obituary lists 1895 as the year of his arrival in Tampa.

23. There are a number of works regarding Tampa's history. Those of note include Grismer, *Tampa* and Mormino and Pizzo, *Tampa*. For an examination of Tampa's nineteenth-century political development, see Welch, *Tampa's Elected Officials* and Robert Kerstein, *Politics and Growth*.

24. U.S. Bureau, Twelfth census, Hillsborough County.

25. Hurner, "Robert Mugge," 23. See Mormino and Pizzo, *Tampa*, 120–28 for an extensive account of Tampa and the Spanish-American War. For an account of Davis and the Spanish-American War, see Orrick and Crumpacker, *Tampa Tribune*, 103 and Nolan, *Fifty Feet*, 192.

26. *Sholes' Directory*; U.S. Bureau, Twelfth census, Hillsborough County.

27. *Polk's Tampa City Directory*, hereinafter cited as *TCD*. Grass widow refers to a woman who leaves her husband and moves to a different community, usually to live with a member of her family. She would not obtain a legal divorce in this instance, largely due to the stigma of divorce during this era.

28. Harner, *Florida Promoters*, 49. The original cabinet card is in the collection of the Tampa Bay History Center. Harner states that Davis, "then aged seventeen, took a full time job in a wholesale and retail hardware store," remaining there for three years; Hillsborough County marriage book U, 230.

29. *TCD*, 1899–1908; U.S. Bureau, Thirteenth census, Hillsborough County; passport application form for George Riley Davis, dated April 22, 1924, National Archives and Records Administration, lists the date of marriage.

30. Grismer, *Tampa*, 224.

31. Harner, *Florida Promoters*, 95; Nolan, *Fifty Feet*, 193; *Tampa Daily Times*, October 20, 1971.

32. *Trow's General Directory*, 1910, 325.

33. Passenger list for the SS *Sarnia*, dated December 21, 1910, National Archives and Records Administration.

34. Passenger list for the SS *Harativis*, dated December 12, 1911, National Archives and Records Administration.

35. U.S. Bureau, Fourteenth census, Duval County; *Polk's Jacksonville City Directory*, hereinafter cited as *JCD*; U.S. Bureau, Fourteenth census, Dade County.

36. *JCD*, 1915–17. The two companies were the Edmunds Investment Co. and Citizens Home Investment Co.

37. See Nolan, *Fifty Feet*, 193 for the best retelling of the hotdog stand legend. Civilian Draft Registration, Duval County, Florida, 1917–18. According to USGENWEB, a widely respected, web-based genealogical resource, some men do not have birth locations listed on their draft cards because they registered on the final draft registration day in 1918 when this information was not recorded. Davis's entry does not include a birth location.

38. *JCD*, 1918. Harner, *Florida Promoters*, 50. U.S. Bureau, Fourteenth census, Dade County; *Atlanta Constitution*, May 1, 1921.

# Chapter 3

39. Rogers, "Paradoxical Twenties" in *New History of Florida*. See George, "Brokers, Binders, and Builders," 27–51 for a thorough treatment of Miami during the 1920s Florida land boom.

40. *Tampa Morning Tribune*, January 30, 1924; Foster, *Castles in the Sand*, 119, 148–155. Foster's work is the most complete treatment of Fisher and his impact on Florida's development in the 1920s.

41. George, "Brokers, Binders, and Builders," 35–7; Rogers, "Paradoxical Twenties" in *New History of Florida*, 293.

42. Nolan, *Fifty Feet*, 193; Harner, *Florida Promoters*, 50; *Atlanta Constitution*, May 1, 1921. Nolan asserts that Davis made $40,000 in ten days.

43. *Miami Herald*, January 11, 1922; *Tallahassee Daily Democrat*, October 1, 1925; *Polk's Miami City Directory*, hereinafter cited as *MCD*.

44. *Miami Herald*, January 11, 1922; *Tallahassee Daily Democrat*, October 1, 1925.

45. *Miami Herald*, January 11, 1922. A photo of the columns appears in a two-page ad that United Realty placed in the center of the *Herald*.

46. Ibid., January 14, 1922.

47. Ibid., January 11, 1922.

48. Ibid.

49. Ibid., January 7, 1922.

50. Ibid., January 11–February 20, 1922. Davis did not place an ad in the January 27, 28 or 30 editions of the *Herald*.

51. Ibid., January 11–18, 1922.

52. Ibid., January 19, 1922. Saying that locals were buying in Davis's subdivision was supposed to assure visitors and newcomers that it was a safe bet.

53. Ibid., January 19–February 20, 1922.

54. *Tampa Sunday Tribune*, May 10, 1953; *Tampa Daily Times*, October 20, 1971; *MCD*, 1922.

55. *Tampa Tribune*, October 20, 1971.

56. *TCD*, 1924; *Tampa Morning Tribune*, February 6, 1924; Grismer, *Tampa*, 390. B.L. Hamner, "Tampa: A City of A Million People in 1936," address delivered to the Tampa Rotary Club, August 24, 1926, Tampa Bay History Center Collection, hereinafter cited as TBHC. The idea that Davis Islands was Hamner's idea is contradicted by what Milton Davis explained in his 1971 interview with the *Tampa Daily Times*. He stated, simply, that coming to Tampa "was D.P.'s idea." Milton had to have known of Hamner's involvement but probably wanted to make his brother appear to be in total control.

57. *MCD*. 1923–1924.

58. *Cocoa Tribune*, December 13, 1923.

59. Amended Plat of Carleton Terrace, filed April 21, 1925, and addition to Carleton Terrace, filed January 13, 1925, Brevard County Property Appraiser's Office. Mr. A.H. Trafford, the son of the founder of Trafford Realty and a Cocoa realtor himself, says he met D.P. Davis when Davis's and Trafford's fathers were working on Carleton Terrace.

60. Brevard County Property Appraiser's Office; Brevard County Property Appraiser's website, www.brevardpropertyappraiser.com.

61. Ibid.

# Chapter 4

62. *TCD*, 1913. The Davis home at 207 South Boulevard has since been demolished. The Lee Roy Selmon Expressway presently passes through the property.

63. Ibid., 1924; Kerstein, "From Annexation," 73.

64. Grismer, *Tampa*, 255; D.B. McKay, "Pioneer Florida Pages," *Tampa Sunday Tribune*, October 26, 1958; Mormino and Pizzo, *Tampa*, 153.

65. Grismer, *Tampa*, 255. The islands were also part of the disputed 1818 Duke of Alagon grant. See Grismer, *Tampa*, 46.

66. McKay, "Pioneer Florida Pages," *Tampa Sunday Tribune*, October 26, 1958; Grismer, *Tampa*, 223–24, 248.

67. *Tampa Morning Tribune*, May 12, 1920 and May 15, 1921; referendum results and the contract between the City of Tampa and Julia Travers, et al., May 9, 1921, filed with the City of Tampa Archives and Records Services (hereinafter cited as TARS); Grismer, *Tampa*, 255. The referendum was strongly supported by the board of trade, which advocated the purchase of both Little and Big Grassy Islands for a total expenditure of $80,000. It is not known why the city only purchased Little Grassy Island, but lack

of funds is a likely cause. By and large, the referendum was supported by the middle- and upper-class precincts within the city, with the majority of opposing votes coming from working-class neighborhoods.

68. *Tampa Daily Times*, October 20, 1971.

69. *Tampa Morning Tribune*, February 5, 1924.

70. L.A. Bize, W.E. Dorchester, G.B. Drason, C.J. Marion, India F. Morris, John Anderson Jr., W.M. Rowlett and John C. Martin to the City of Tampa, February 12, 1924, TARS. Only Bize, Dorchester and Rowlett lived on Bayshore Boulevard. Covington, "Story of Davis Islands," 28, note 13, points out that the real problem would not be the view along Bayshore. Instead "a greater danger would arise when the natural flushing of the bay would be ended by the dredging and terrible odors and peeling of house paint would develop to plague the home owners for many years." While the islands did interrupt the "natural flushing" of the bay, the Hillsborough River had been dammed years before, impeding its flow into Hillsborough Bay. It did not become a serious problem until the islands were dredged.

71. Karl Whitaker to the City of Tampa, February 12, 1924, TARS.

72. Ibid; Kerstein, *Politics and Growth*, 308n.1. Kerstein mentions two such subdivisions in Hillsborough County from this time period: Tropical Pines and North Bon-Air. Additionally, deeds covering Davis Islands property in the 1950s carried such restrictions. One such deed is in the collection of the Tampa Bay History Center.

73. Optimist Club of Tampa to the City of Tampa, *TARS*; Christopher, *Tampa's People*, 70.

74. Grismer, *Tampa*, 256. While many sources mention the purchase price and families involved, no one has connected the excessive price the Whitakers charged Davis to Karl Whitaker's opposition to the island project.

75. Contract between the City of Tampa and David P. Davis, signed February 26, 1924, *TARS*.

76. Ibid.

77. Ibid.

78. Ibid.

79. *Tampa Morning Tribune*, April 23, 1924; Grismer, *Tampa*, 256; Davis file, *TARS*.

80. Grismer, *Tampa*, 256. The justices were divided 3–2 on the issue.

81. *Tampa Morning Tribune*, November 9, 1924. Al Burgert, of the Burgert Brothers photography firm, has also laid claim as the first person to cross the temporary bridge onto Davis Islands, doing so on April 22, 1925. Though the Burgert Brothers were contracted by Davis to take extensive photographs of the progress on Davis Islands—including the photo of Milam and D.P. Davis

Jr.—the bridge had been open for five months before the photograph of Al Burgert was taken. It may be that it was another bridge on the islands, not the main bridge. See Leland Hawes, "How Davis Islands Emerged From the Bay," *Tampa Tribune*, July 10, 1988, for Burgert's claim.

82. Covington, "Story of Davis Islands," 28 n.18. Davis made every effort to mention the cost of his Davis Islands investment. He placed the $30 million price tag in almost every brochure, advertisement and news story produced between 1924 and 1926.

83. *Tampa Morning Tribune*, November 2, 1924; *Tampa Tribune*, January 14, 1990; Meyer, "Davis Islands," 50.

84. Plan of Davis Islands, TBHC. The proposed Davis Arms Hotel, which was to be located on a waterfront lot at the western end of Biscayne Avenue, was an exception to the rule of apartments and hotels remaining close to Davis Boulevard.

85. Plan of Davis Islands, TBHC.

86. Ibid.

# CHAPTER 5

87. *Tampa Morning Tribune* and *Tampa Daily Times*, August–November 1924; *Merriam Webster's*; Dunn, *WDAE*, 19; Roberts, *Florida*. Popular publications of the time included *Suniland* magazine and *Rinaldi's Guidebook of South Florida*. See Meyer for an examination of Davis's advertising campaign in 1924.

88. Grismer, *Tampa*, 256; Florida State Archives, short biography of Arthur and Richard Milam.

89. *Tampa Morning Tribune*, August 26, 1924; Plan of Davis Islands, TBHC. Each newspaper article about the various land sales mentions which section had just been sold. The yacht club referred to here should not be confused with the now-existing yacht club at the southern end of the islands.

90. *Tampa Morning Tribune*, October 5, 1924.

91. See Stewart, "Madness," 66 for examples of this in South Florida. Photographs of Davis Properties buses are in the collections of both the TBHC and the Tampa–Hillsborough County Public Library System. Examples of these booklets are in the Hillsborough County Collection, TBHC.

92. *Tampa Morning Tribune*, September 23, 1924.

93. Ibid., October 14, 1924.

94. Sanborn Fire Insurance Company, Map of Tampa, 1931 (vol. 4); M. Leo Elliott Collection, Tampa Bay History Center Collection.
95. *TCD*, 1925–1932; Hillsborough County Property Appraisers Office.
96. Covington, "Story of Davis Islands," 26; Acosta, et al., *City of Tampa*, 15–16. The original Palace of Florence architectural plans, created by M. Leo Elliott and his staff, are in the TBHC collection. Both Hudson Manor and the Palace of Florence are locally landmarked by the City of Tampa.
97. Orrick and Crumpacker, *Tampa Tribune*, 115; See Turner, *Gasparilla* for a general history of Tampa's Gasparilla festival.
98. Turner, *Gasparilla*, 17–78. The trend of the first maid one year becoming the queen the next began in the second inauguration with Queen Gasparilla II, Mary Carnes, who was first maid the previous year. This continued through 1917, was renewed in 1923 and then followed less strictly after the mid-1930s.
99. *Tampa Morning Tribune*, October 11, 1925; *Tampa Daily Times*, October 11, 1925.
100. Orrick and Crumpacker, *Tampa Tribune*, 116; *Tampa Daily Times*, October 20, 1971; Foster, *Castles in the Sand*, 297; *Atlanta Constitution*, December 13, 1925; author interviews with Edwin K. Nelson Jr., George Riley Davis, II, and John Rudolph.
101. *Tampa Daily Times*, October 20, 1971.

# CHAPTER 6

102. St. Augustine *Evening Record*, October 15, 1925.
103. See Gannon, "First European Contacts," in *New History of Florida*, 16–39 for a complete history of St. Augustine's early history.
104. Buker and Waterbury, *Oldest City*, 226–27; Foster, *Castles in the Sand*, 139.
105. *Tallahassee Daily Democrat*, November 4, 1925.
106. Bowen, *Bridge to A Dream*, 17; Susan R. Parker, "Davis Shores street names recall St. Augustine history," *St. Augustine Record*, November 28, 2009; Knetsch, *Florida's Seminole Wars*, 99.
107. *Tallahassee Daily Democrat*, October 17, 1925; Davis Shores file, St. Augustine Historical Society, hereinafter cited as SAHS; Bowen, *Bridge to A Dream*, 8–10. Foster's title of adjutant general was an honorary one. Davis was also an officer, a lieutenant colonel, in the Florida National Guard under Governor John Martin, see Nolan, *Fifty Feet*, 196.
108. Bowen, *Bridge to A Dream*, 21.
109. *Tallahassee Daily Democrat*, October 17, 1925.

110. Davis Shores file, SAHS; Buker and Waterbury, *Oldest City*, 227–28.

111. *Tampa Morning Tribune*, November 15, 1925; Bowen, *Bridge to A Dream*, 14.

112. *St. Augustine Evening Record*, October 15, 1925. Bowen, *Bridge to A Dream*, 15. According to Bowen, "removal of fill from the bay resulted in an additional $300,000 in costs" for the Bridge of Lions "when it became necessary to deepen the pier and abutment foundations" on the Davis Shores side. The extra expense added almost 50 percent to the overall cost of the bridge.

113. *TCD*, 1920–26; Covington, "Story of Davis Islands," 27.

114. Ibid., 26.

115. Parks, *Miami*, 118–26.

116. Both the *New York Times* and *Nation* quotes are from Gannon, *Florida*, 82.

117. First National Bank collection, Florida State Archives. For insight into Knight's influence in Tampa's growth, see Kerstein, *Politics and Growth*. Evidence of Davis Islands being incomplete lies in the advertisements placed in the *Tampa Morning Tribune* after Davis sold the development and in Burgert Brothers photographs of Davis Islands.

118. *Tampa Morning Tribune*, August 3, 1926; Covington, "Story of Davis Islands," 27.

119. Passenger list, RMS *Homeric*, September 11, 1926, National Archives and Records Administration; interview with George Davis II, 2005.

# CHAPTER 7

120. *Tampa Daily Times*, October 13, 1926; interview with George Davis II, 2005.

121. Sumter Lowry, *Ole 93*, 37–8.

122. Orrick and Crumpacker, *Tampa Tribune*, 116; Nolan, *Fifty Feet*, 226.

123. *Tampa Daily Times*, October 20, 1971.

124. *Atlanta Constitution*, October 16, 1926.

125. *St. Petersburg Evening Independent*, November 2, 1926.

126. *Atlanta Constitution*, October 26, 1926; *St. Petersburg Evening Independent*, November 2, 1926.

127. Interview with George Davis II, 2005.

128. All attempts to locate interior photographs of rooms on the ship have been unsuccessful. The *Majestic* herself was sold to the British navy for training purposes and burned accidentally in 1939.

129. *Tampa Daily Times*, October 20, 1971; Nolan, *Fifty Feet*, 225; Orrick and Crumpacker, *Tampa Tribune*, 116.

130. Interview with George Davis II, 2005.

131. *St. Petersburg Evening Independent,* November 2, 1926; *Atlanta Constitution,* October 15, 1926; Passenger lists, SS *Berengaria,* October 29, 1926 and SS *Deutschland,* November 1, 1926, National Archives and Records Administration.

132. *American Weekly,* appearing in the *San Antonio (Texas) Light,* accessed via Google News Archive, undated but copyrighted 1927.

133 Ibid.

134. Hillsborough County, *Davis Islands,* 20.

135. Ibid.

136. Bowen, *Bridge to a Dream,* 20.

137. *Tampa Morning Tribune,* October 10, 1926.

138. *TCD,* 1927–30.

139. *Tampa Morning Tribune,* May 16, 1928. The name of the holding company for Davis Islands changed from Davis Islands Investment Company to Davis Islands Incorporated between 1926 and 1928.

140. *Life on Davis Islands,* January 30, 1927.

141. Ibid., January 15, 1929.

142. Ibid.; *Tampa Morning Tribune,* September 15, 1929.

143. Ibid.

144. Ibid., August 25 and September 15, 1929.

145. D.P. Davis Properties, *Life on Davis Islands*; *TCD,* 1930. Both *Florida's Water Spot* and *Life on Davis Islands* are in the TBHC collection.

146. *TCD,* 1924–30. The following is the total page count, real estate advertising page count and percentage of pages devoted to advertising from 1926 to 1930. In the 1926 directory, there were seven real estate related categories. These remained roughly the same through 1930, with a few exceptions.

| YEAR | TOTAL PAGE COUNT | REAL ESTATE ADVERTISING PAGE COUNT | PERCENTAGE |
|------|------------------|-----------------------------------|------------|
| 1926 | 108 | 25 | 23 |
| 1927 | 71 | 9 | 12 |
| 1928 | 59 | 6.5 | 11 |
| 1929 | 46 | 3.5 | 7 |
| 1930 | 34 | 2 | 5 |

147. *Tampa Daily Times,* October 20, 1971.

148. *TCD,* various years; Obituary of George Hodgson, *Tampa Tribune,* December 7, 1959.

149. *Tampa Morning Tribune*, February 14, 1930; PCA, biography of Howell A. Davis and family.

150. *TCD*, 1925–52.

151. Ibid., 1931.

152. Ibid., 1936.

153. *Tampa Morning Tribune*, July 17, 1934; February 6, 1930.

154. Ibid., November 7, 1937; January 27, 1938; January 30, 1938.

155. Federal Writers' Project, *Florida*, 289.

156. Ibid.; *Tampa Tribune*, April 12, 2001. The Hill murals have been conserved and are installed at Tampa International Airport's Airside E.

157. *Tampa Morning Tribune*, October 23, 1945.

158. *Tampa Daily Times*, March 15, 1940; December 30, 1940.

159. *TCD*, 1941; Hillsborough County Property Appraiser's website; Mormino and Pizzo, *Tampa*, 242–43. The Property Appraiser's website, www.hcpafl.org is a fairly reliable source for finding the dates of construction for buildings in Hillsborough County.

160. Dunn, *Tampa*, 152; *Tampa Morning Tribune*, April 12, 1950.

161. For information regarding the attempted closure of Peter O. Knight Airport, see the Roslyn Burritt Papers in the holdings of the University of South Florida Library, Special Collections Department.

162. Burritt Papers.

163. *Tampa Morning Tribune*, January 11, 1945.

164. Grismer, *Tampa*, 286; *Tampa Morning Tribune*, October 23, 1945.

165. *Tampa Morning Tribune*, October 23, 1945.

166. *TCD*, 1936 and 1941.

167. Mormino and Pizzo, *Tampa*, 242.

168. Life history of "Enrique and Amanda (Cubans)," taken by Stetson Kennedy for the Federal Writers' Project, 1936–40. Subjects interviewed on January 3, 1939 in the Ybor City section of Tampa, Florida. Tampa's unique ethnic history, dating to the earliest days of the cigar industry, included people from Italy, Spain and Cuba, all of whom are colloquially referred to as Latins.

169. Mormino and Pozzetta, *Immigrant World*, 320.

170. Ibid., 292.

171. *TCD*, 1931 and 1936; Mormino and Pozzetta, *Immigrant World*, 298.

172. Ibid., 299.

173. Rebecca Perez (granddaughter of Miguel and Grace Díaz), in discussion with the author, April 18, 2001; *TCD*, 1947 and 1953–54.

174. *TCD*, 1946.

175. Mormino and Pozzetta, *Immigrant World*, 304; *TCD*, 1949 and 1950; Hawes, "Tony Pizzo," 5.

176. Dick A. Greco Jr., in discussion with the author, April 18, 2001. Notes in possession of author; *TCD*, 1960–1969; Hillsborough County Property Appraiser's website.

177. *TCD*, 1946 and 1951; *Tampa Morning Tribune*, December 31, 1950.

178. An example of a 1950 Davis Islands deed with a restrictive covenant is in the TBHC collection.

179. *Tampa Morning Tribune*, April 12, 1950; *Tampa Sunday Tribune*, December 28, 1952.

180. *Tampa Morning Tribune*, August 10–12, 1954.

181. *TCD*, 1952 and 1953–54. Davis Islands, Inc. is not listed in the combined 1953–54 city directory, so it is unclear when the company officially went out of business.

182. *TCD*, 1951, 1956 and 1961.

183. *TCD*, 1951, 1956 and 1958.

184. Hillsborough County Property Appraiser's website; Mormino and Pizzo, *Tampa*, 242; Burgert Brothers photograph from the University of South Florida Library, Special Collections Department, dated June 4, 1958 (negative # V3232-2).

185. *TCD*, 1956 and 1961.

186. Tabulated by counting structures in the city directory for 1961 (1,510) and structures on today's Davis Islands streets from the Hillsborough County Property Appraiser's office (2,027). Both numbers are estimates, but the general percentage is fairly accurate.

187. *Tampa Morning Tribune*, October 10, 1955.

188. *TCD*, 1961.

189. William "Skip" North, in discussion with the author, 2003. North's grandfather, Byron Webb, owned the home on Hyde Park Avenue.

190. *Tampa Tribune*, January 27, 1967.

191. Ibid.; Martha Johnson (daughter of Carl Moseley), in discussion with the author, 2013.

192. *Tampa Tribune*, January 27, 1967.

193. Interview with Rebecca Pérez, April 18, 2001.

194. *Tampa Sunday Tribune*, May 10, 1953.

# CHAPTER 8

195. *Tampa Tribune*, March 14, 2013.

# BIBLIOGRAPHY

## NEWSPAPERS

*Atlanta Constitution*
*Cocoa Tribune*
*Life on Davis Islands*
*Miami Herald*
*New York Times*
*St. Augustine Record* (encompasses *St. Augustine Evening Record*)
*St. Petersburg Evening Independent*
*St. Petersburg Times*
*Tallahassee Daily Democrat*
*Tampa Daily Times*
*Tampa Tribune* (encompasses *Tampa Morning Tribune* and *Tampa Sunday Tribune*)

## GOVERNMENT DOCUMENTS

Civilian Draft Registration. Duval County, Florida, 1917–18.
Marriage certificates. Hillsborough County, Florida.
Marriage certificates. Putnam County, Florida.
Passenger lists from the National Archives and Records Administration.
U.S. Bureau of the Census. Eighth Census of the United States, 1860: Population.

————. Ninth census of the United States, 1870: Population.

————. Tenth census of the United States, 1880: Population.

————. Twelfth census of the United States, 1900: Population.

————. Thirteenth census of the United States, 1910: Population.

————. Fourteenth census of the United States, 1920: Population.

WPA Oral Histories. National Archives and Records Administration.

# INTERVIEWS

Davis, David Paul, Jr. Interview with the author. Walnut Creek, California, March 14, 2005.

Davis, George Riley, II. Interview with the author. Woodland, California, March 15, 2005.

Greco, Dick A. Correspondence with the author. Tampa, Florida, April 18, 2001.

Hawes, Leland M., Jr. Interview with the author. Tampa, Florida, April 12, 2001.

Johnson, Martha. Telephone interview with the author. Tampa, Florida, May 9, 2013.

Nelson, Edwin K., Jr. Interview with the author. Tampa, Florida, November 17, 1998.

North, William "Skip." Interview with the author. Tampa, Florida, May 4, 2013.

Perez, Rebecca. Telephone interview with the author. Tampa, Florida, April 18, 2001.

Randolph, John. Telephone interview with the author. Tampa, Florida, February 23, 2004.

# REFERENCE BOOKS

*Merriam Webster's Collegiate Dictionary*. 10th ed. Springfield, MA: Merriam Webster, Inc., 1995.

*Polk's Jacksonville City Directory*. Jacksonville, FL: R.L. Polk and Company.

*Polk's Miami City Directory*. Jacksonville, FL: R.L. Polk and Company.

*Polk's Tampa City Directory*. Jacksonville, FL: R.L. Polk and Company.

*Putnam County, Florida: Marriages, 1849–1890.* Putnam County Genealogical Society Quarterly Journal (Palatka, Florida) 3 (Spring/Summer/Fall 1985).

*Sanborn Fire Insurance Company Maps of Tampa.* Chicago: Sanborn Fire Insurance Company.

*Sholes' Directory of the City of Tampa.* Savannah, GA: A.E. Sholes.

*Trow's General Directory of the Boroughs of Manhattan and the Bronx, City of New York.* New York: Trow Directory, Printing and Bookbinding Company.

## MUSEUMS, ARCHIVES AND LIBRARIES

Brevard County Property Appraiser's Office.

City of Tampa Archives and Records Services.

Florida State Archives.

Putnam County Archives.

St. Augustine Historical Society.

Tampa Bay History Center.

Tampa–Hillsborough County Public Library System.

University of South Florida, Tampa Campus Library Special Collections.

## ELECTRONIC RESOURCES

Ancestory.com.

Google News Search.

USGENWEB Online Genealogical Research.

## ARTICLES, BOOKS AND MANUSCRIPTS

Acosta, Del, et al. *City of Tampa: Local Historic Landmarks and Local Historic Districts.* Tampa, FL: City of Tampa, 2003.

Blakey, Arch F. *Parade of Memories: A History of Clay County, Florida.* Green Cove Springs, FL: Clay County Bicentennial Steering Committee, 1976.

Bowen, Beth Rogero. *Bridge to a Dream: Building the Bridge of Lions and Davis Shores, 1925–27*. St. Augustine, FL: St. Augustine Historical Society, 2010.

Browne, Jefferson. *Key West: The Old and the New*. Originally published in St. Augustine, 1912; reprinted Gainesville: University of Florida Press, 1973.

Buker, George, and Jean Parker Waterbury. *Oldest City: St. Augustine, Saga of Survival*. St. Augustine, FL: St. Augustine Historical Society, 1983.

Christopher, W. Scott. *Tampa's People with a Purpose*. Tampa, FL: Greater Tampa Chamber of Commerce, 1993.

Covington, James. "The Story of Davis Islands, 1924–1926." *Sunland Tribune* 4 (November 1978).

Davis Islands, Incorporated. *Florida's Wonder Spot*. Tampa: Florida Grower Press, 1928.

D.P. Davis Properties. *Life on Davis Islands*. Louisville, KY: Courier-Journal Lithography, 1925.

Dunn, Hampton. *Tampa: A Pictorial History*. Norfolk, VA: Donning Company, 1985.

———. *WDAE: Florida's Pioneer Radio Station*. Tampa, FL: Fort Brooke Press, 1972.

Federal Writers' Project. *Florida: A Guide to the Southernmost State*. New York: Oxford University Press, 1939.

Foote, Shelby. *The Civil War: A Narrative*. New York: Random House, 1974.

Foster, Mark S. *Castles in the Sand: The Life and Times of Carl Graham Fisher*. Gainesville: University Presses of Florida, 2000.

Gannon, Michael, ed. *Florida: A Short History*. Gainesville: University Presses of Florida, 1993.

———. *The New History of Florida*. Gainesville: University Presses of Florida, 1996.

George, Paul. "Brokers, Binders, and Builders: Greater Miami's Boom of the Mid-1920s." *Florida Historical Quarterly* 65 (July 1986).

Grismer, Karl. *Tampa: A History of the City of Tampa and the Tampa Bay Region of Florida*. St. Petersburg, FL: St. Petersburg Publishing Company, 1950.

Harner, Charles E. *Florida Promoters*. Tampa, FL: Trend House, 1973.

Hartman, David W., and David Coles. *Biographical Rosters of Florida's Confederate and Union Soldiers, 1861–65*. Wilmington, NC: Broadfoot Publishing Company, 1995.

Hawes, Leland. "Tony Pizzo: 1912–1994," *Sunland Tribune* 20 (November 1994).

Hillsborough County Planning Commission. *Davis Islands Plan: Tampa Urban Case Study*. Tampa, FL: Hillsborough County Planning Commission, n.d.

Hurner, Margaret Regener. "Robert Mugge—Pioneer Tampan." *Sunland Tribune* 15 (November 1989).

Kerstein, Robert. "From Annexation to Urban Renewal: Urban Development in Tampa During the 1950s and 1960s." *Tampa Bay History* 19, no. 1 (Spring/Summer 1997).

———. *Politics and Growth in Twentieth Century Tampa*. Gainesville: University Presses of Florida, 2001.

Kitchens, Allegra. "Palatka, 150...and Counting." *Welcome Magazine* (Palatka, Florida) (Winter/Spring 2003).

Kite-Powell, Rodney. "The Continued Evolution of Davis Islands, 1931–61," *Sunland Tribune* 27 (December 2001).

———. "David Paul Davis' Unfulfilled Dream: Davis Islands from October 1926 until the Crash of 1929." *Sunland Tribune* 25 (December 1999).

Knetsch, Joe. *Florida's Seminole Wars, 1817–58*. Charleston, SC: Arcadia Publishing, 2003.

Lanier, Sidney. *Florida: Its Scenery, Climate, and History.* Originally published in Philadelphia, 1875; reprinted Gainesville: University of Florida Press, 1973.

Lowry, Sumter. *Ole '93.* Tampa, Florida: privately published, 1970.

Mack, Thomas. *Citrifacts II: A Portion of Florida Citrus History.* Lakeland, FL: Associated Publishers Corporation, 1998.

Meyer, Thomas H. "Davis Islands: The Booming Two Month Transformation of Tampa's Mudflats into Tampa's Dreamscape." *Sunland Tribune* 18 (November 1992).

Michaels, Brian. *The River Flows North: A History of Putnam County.* Palatka, FL: Putnam County Archives and History Commission, 1976.

Mormino, Gary R., and Anthony P. Pizzo. *Tampa: The Treasure City.* Tulsa, OK: Continental Heritage Press, 1983.

Mormino, Gary R., and George E. Pozzetta. *The Immigrant World of Ybor City: Italians and Their Latin Neighbors in Tampa, 1885–1985.* Gainesville: University Press of Florida, 1987.

Morris, Allen. *Florida Place Names.* Coral Gables, FL: University of Miami Press, 1974.

Nolan, David. *Fifty Feet in Paradise.* New York: Harcourt Brace Jovanovich, 1984.

Orrick, Bentley, and Harry L. Crumpacker. *The Tampa Tribune: A Century of Florida Journalism.* Tampa, FL: University of Tampa Press, 1998.

Parks, Arva Moore. *Miami: The Magic City.* Tulsa, OK: Continental Heritage Press, 1981.

Rambler. *Guide to Florida.* Originally published in New York, 1875; reprinted Gainesville: University of Florida Press, 1964.

Roberts, Kenneth L. *Florida.* Tampa, FL: D.P. Davis Properties, 1926.

Ryan, Thomas D. *Clay County, Florida: A Sketch of Its Past.* Green Cove Springs, FL: Clay County Historical Commission, 1972.

Sifakis, Stewart. *Compendium of the Confederate Armies: Florida and Arkansas*. New York: Facts on File, 1992.

Stewart, Doug. "The Madness that Swept Miami." *Smithsonian* (January 2001).

Turner, Nancy. *Gasparilla: 1904–79*. Tampa, FL: Cider Press, 1979.

Welch, Curtis. *Tampa's Elected Officials*. Tampa, FL: City of Tampa, 1997.

# INDEX

# ABOUT THE AUTHOR

Rodney Kite-Powell is the Saunders Foundation curator of history at the Tampa Bay History Center, where he joined the staff in 1994. He received a bachelor of arts in history from the University of Florida and a master of arts in history from the University of South Florida.

Born and raised in Tampa, he has written extensively on the history of Tampa and Hillsborough County and is the editor of *Tampa Bay History*, a regional history journal published through a partnership between the History Center and the University of South Florida Libraries' Florida Studies Center.

In addition to his duties at the History Center, he has served as an adjunct professor of history at the University of Tampa, where he taught a course on the history of Florida. He currently lives in Tampa with his wife and stepson.

*Visit us at*
www.historypress.net
..................................................................
*This title is also available as an e-book*